D1578758

VISIONS

THE
**PAUL HAMLYN
LIBRARY**

———•———

DONATED BY

THE PAUL HAMLYN

FOUNDATION

TO THE

BRITISH MUSEUM

———•———

opened December 2000

WITHDRAWN

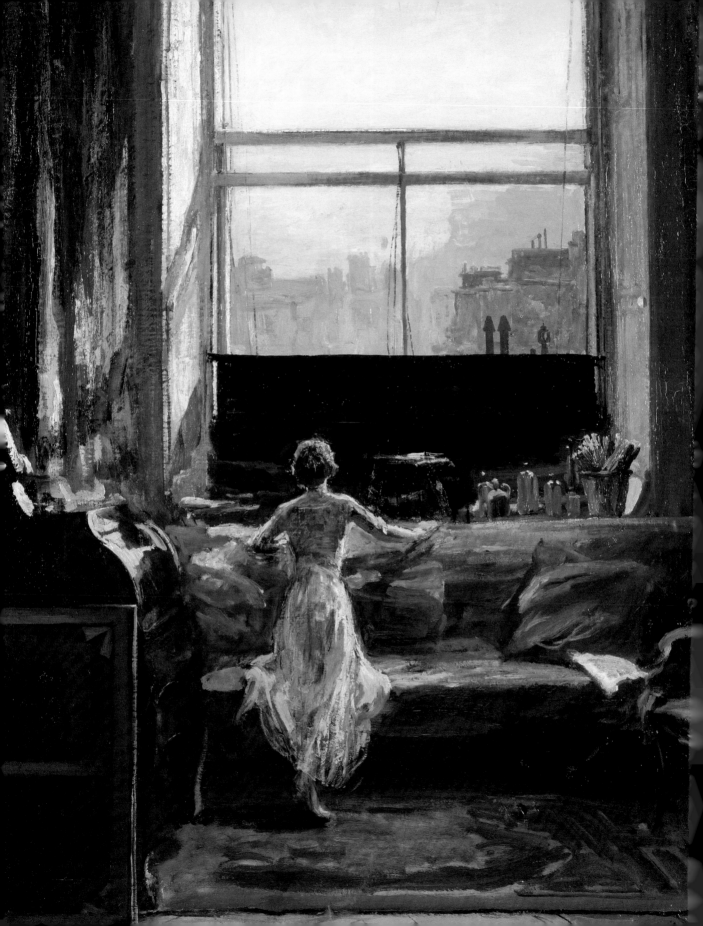

VISIONS
A Celebration of Irish Art from the Ulster Museum

Eileen Black and Anne Stewart

Ulster
Museum

explore/engage/enjoy

Text Copyright © National Museums Northern Ireland and the authors

ISBN 0 900761 54 7

Catalogue designed by Jason Ellams
Printed by Nicholson & Bass Limited

Front cover image:
detail of Jack B. Yeats, *On Through the Silent Lands*, 1951 (p. 59)
Back cover image:
detail of Thomas Bate, *Thomas, Lord Coningsby (1656–1729),*
Seated in a Romanticised Landscape, with a View of the North Prospect
of Hampton Court, Herefordshire, in the Background, 1692 (p. 11)
Frontispiece:
detail of Sir John Lavery, *Daylight Raid from my Studio Window,*
7th July 1917, 1917 (p. 41)
pp. 8,9:
detail of James Arthur O'Connor, *Scene in Co. Wicklow*, 1820 (p. 28)
pp. 110,111:
Bartholomew Colles Watkins, *Ecclesiastical Ruins on Inniscaltra, or Holy*
Island, Lough Derg, Co. Galway, after Sunset, c.1863 (p. 35)

709.415 BLA

THE
BRITISH
MUSEUM DRAWN
THE PAUL HAMLYN LIBRARY

The works in this book have been selected not only to highlight the best of the Ulster Museum's Irish art collection from the late seventeenth century to the present day but also to illustrate its breadth and variety. To that end, there is a wide spread of portraiture, from John Michael Wright's elegant portrait of Robert King, 2nd Baron Kingston of 1676 to Neil Shawcross's naïve and quirky image of Francis Stuart of 1978, complete with Stuart's pet rabbit and cat. A broad range of landscape painters is also included, from major figures of the eighteenth and nineteenth centuries such as William Ashford, George Barret and James Arthur O'Connor to twentieth-century 'local lads' like Paul Henry, Frank McKelvey and Basil Blackshaw. Several artists are represented by more than one work. When this occurs, the aim is to indicate variety of subject matter; also, to show changes in style and technique, as with, for example, Jack B. Yeats, Louis le Brocquy, Colin Middleton and William Scott. In 1929, Sir John Lavery gave thirty-four of his paintings to the Belfast Museum and Art Gallery and, in recognition of the gift, six paintings representing all periods of his career have been included.

Since the late 1950s, the Ulster Museum has built up a major collection of modern and contemporary Irish art. The works in the later section of the book have been selected to represent, as comprehensively as possible, recent developments in Irish art. As with the historic section, landscape and portraiture continue to play an important role and one of the most interesting aspects of the collection is the manner in which traditional themes in Irish art reappear in the work of contemporary artists. Two recent acquisitions by Willie Doherty, *Apparatus*, a series of forty photographs of Belfast and *Ghost Story*, a seminal video installation, use new media in a powerful and challenging way that suggests new directions and possibilities in the development of Irish art.

This impressive selection of works from the Ulster Museum's Irish collection reflects the richness and diversity of a unique tradition of artistic development and imagination across more than three hundred years.

The works touch individually on enduring themes, some universal and others particular to Ireland, north and south. Collectively, they offer powerful insight into our social, economic, political and artistic life spanning four centuries. As such, they are a testament to the important role of public collecting for today and for future generations.

Dating from the late seventeenth century to the early twenty-first, the selection encompasses portraits, still-life and landscapes, through representational and abstract styles. Besides well-known figures such as George Barret, Roderic O'Conor and Jack B. Yeats, numerous artists feature with particular connections to the north of Ireland. For example, the work of William Conor, Paul Henry, Sir John Lavery and, more recently, of Willie Doherty allows us to observe patterns of life and experience which are part of our shared inheritance today.

This combination of mainstream and local, as well as the broad sweep of time covered, gives the collection a special identity and relevance. The works are of their time and yet timeless.

I am grateful to my colleagues, Dr Eileen Black and Anne Stewart, who made this thoughtful selection. Their book opens a window which will surely encourage and enable reflection, inspiration and the pure enjoyment of the Ulster Museum's marvellous collection.

Tim Cooke
Director
National Museums Northern Ireland

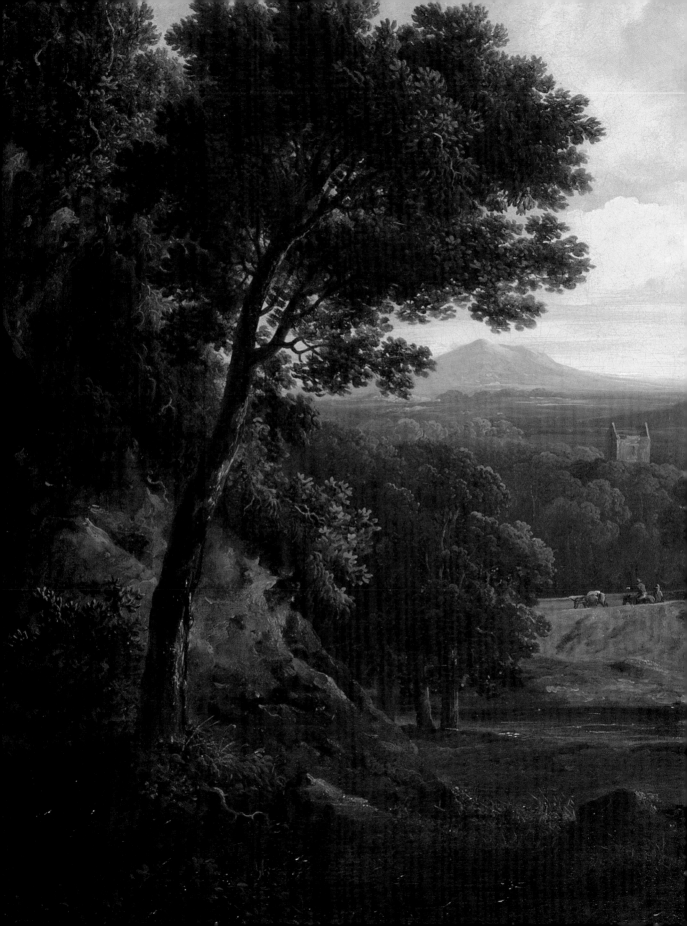

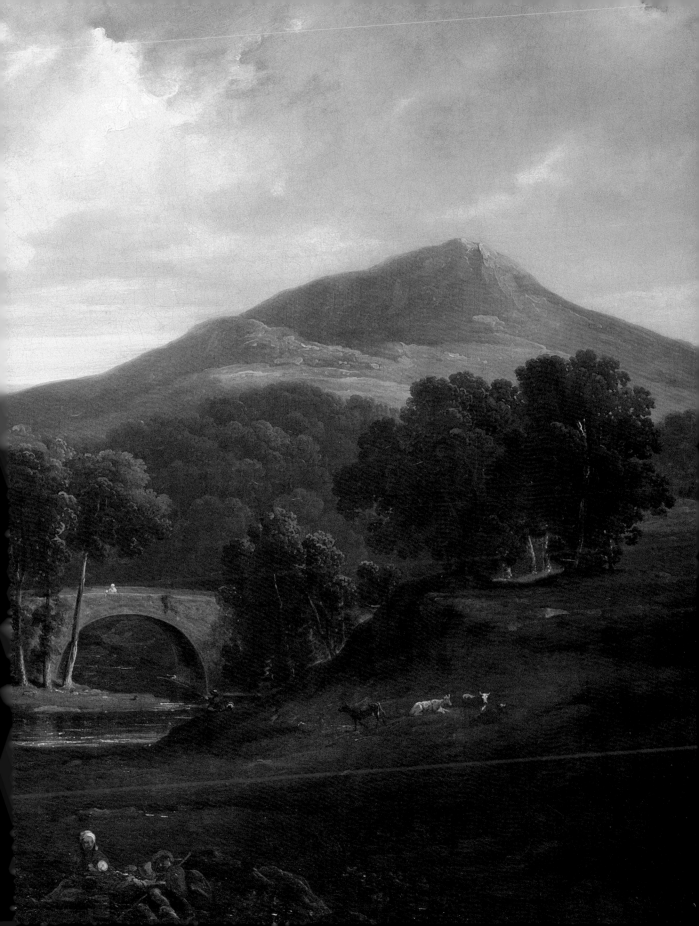

JOHN MICHAEL WRIGHT

1617-94

Robert King, 2nd Baron Kingston
(1657–93)

Probably 1676
Oil on canvas
239.4 x 146.6 cm
Purchased 1959
U216

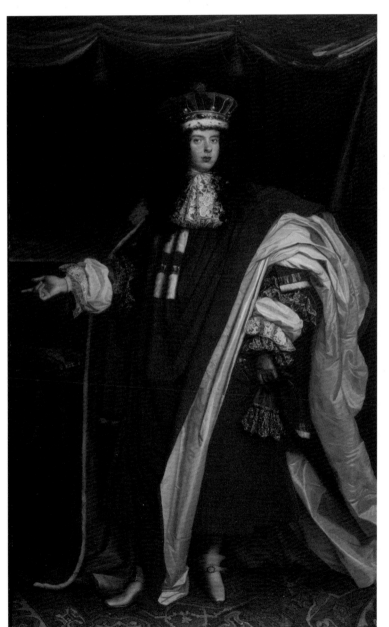

Attired in parliamentary robes and coronet, nineteen-year-old Baron Kingston cuts a dashing figure in this resplendent piece. The portrait, however, is something of an anachronism, as coronets are not normally worn with parliamentary robes but with coronation robes; moreover, a peer would never wear his robes tossed nonchalantly over his shoulder like this and the quantity of material has been greatly exaggerated. Interestingly, Irish peers, almost alone, liked to be portrayed wearing their coronets, though it was more in keeping with artistic convention to place the coronet beside one on a cushion. The portrait was probably painted in London in 1676 to commemorate Kingston's accession to the baronetcy.

Wright worked in Rome and Flanders from the late 1640s and returned to Commonwealth England in 1656, where he established a successful portrait practice, despite being a Catholic. He was subsequently patronised by Charles II and James II but lost favour at the court of William III. Between 1679 and 1680 he was in Dublin, where he executed a number of important commissions, including Sir Neil O'Neill in Irish dress (Tate Britain). The portrait of Kingston is a fine example of his skill with draperies and with the texture of materials.

EB

THOMAS BATE

fl.c.1692

*Thomas, Lord Coningsby
(1656–1729), Seated in a
Romanticised Landscape, with
a View of the North Prospect of
Hampton Court, Herefordshire,
in the Background*

1692
Oil on canvas
78.8 x 88.9 cm
Signed and dated, bottom left,
T.Bate fecit 92
Purchased 1973
U1883

The atmosphere of this painting, with its
lowering sky and dark mysterious woods,
seems to epitomise the romantic medieval
fantasy world which Coningsby, MP for
Leominster, Herefordshire, tended to inhabit.
A flamboyant character, he was obsessed with
knightly prowess and spent much time re-
enacting the past at his seat at Hampton Court,
Herefordshire, through tournaments and
jousting. Appropriately, the painting shows
him seated before the house, holding a jousting
lance and wearing a colourful version of Roman
dress (a convention popular in seventeenth-
century portraiture).

This is the only known signed work by Bate,
an obscure but interesting figure, who is said
to have been famous for painting portraits on
glass and to have lived mostly in Ireland. He also
seems to have worked as a topographical painter,
as indicated by the attribution of two landscapes
to him: *Dublin from the Phoenix Park* of c.1699
(on loan to the Bath Preservation Trust) and a
view of Blessington, dating from the first decade
of the eighteenth century (private collection).[1]
The portrait may have been painted in Ireland,
as Coningsby, who served with William III at the
Battle of the Boyne of 1690, was one of the three
Lords Justices of the country, 1690–92.

EB

JAMES LATHAM

1696–1747

*Captain Charles Janvre de
la Bouchetière (d.c.1743)*

c.1730–35
Oil on canvas
126 x 97 cm
Purchased 1978
U2513

The sophistication which distinguishes
the work of James Latham is plain to see in
this commanding portrait of Captain de la
Bouchetière, a Huguenot cavalry officer whose
family fled France after the revocation of the
Edict of Nantes in 1685, to settle in Dublin.
(The Edict had granted civil liberties to French
Protestants.) The direct gaze, emphasis on
characterful expression and delicate handling
of paint are typical of Latham, as is the attention
paid to the embroidery on de la Bouchetière's
coat. The portrait exudes an air of elegance
and dignity.

Uncertainty surrounds Latham's early career
and place of birth, which is thought to be Co.
Tipperary. That he was in Antwerp 1724–25
is known from the records of the Antwerp Guild
of St Luke. Then aged twenty-eight, his visit may
have been undertaken during travels he was
making on the Continent. A French influence has
been detected in his work (de la Bouchetière's
pointing right hand is a gesture often found in
French painting) and he may have spent time in
Paris but this, too, is uncertain. Whatever about
these possibilities, he was in Dublin by c.1730
and by the 1740s, had come to be regarded
as the most accomplished portrait painter
in the country.

EB

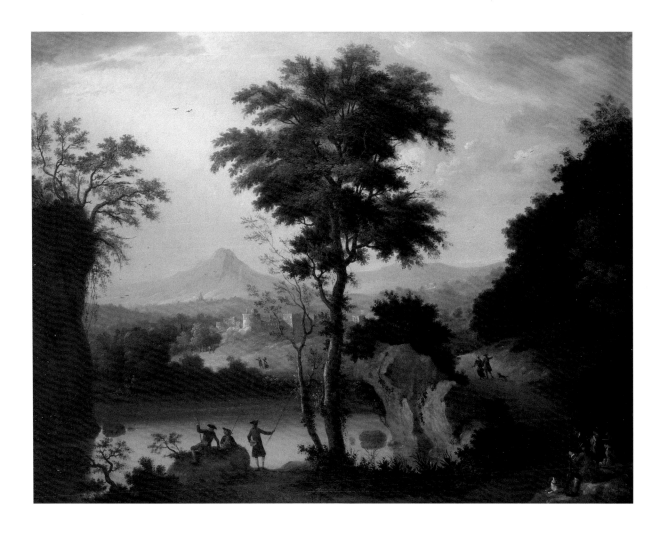

RICHARD CARVER

d.1754

Landscape with Figures

Probably 1740s
Oil on canvas
101 x 131.5 cm
Signed bottom left,
Rd Carver (*d* is indistinct)
Purchased 1968
U132

Landscape with Figures, attributed to Richard Carver by Crookshank and Glin some thirty years ago, is an interesting amalgamation of effects, with the group of sportsmen in contemporary dress adding a somewhat homely touch to the otherwise classical scene. The painting is composed in a typical Claudean manner, that is, with a darkish foreground, lighter middle distance fading into a hazy blue background and coulisses (wings) at either side. The tree in the centre, probably added to create a sense of depth, rather fails in its purpose and serves only to cut the picture in half. Interestingly, Carver used a similar device in another work (likewise attributed to him by Crookshank and Glin), auctioned at Christie's, London, 14 May 2004, lot 104.

The Carvers, Richard and his son Robert (c.1730–91) were landscape painters from Waterford. Little is known of Richard's career except that he was apprenticed to an obscure painter, Edward Harling, in 1697 and that he eventually practised in Dublin. He was also the teacher of Robert, who became a well-known theatrical scene painter in Dublin and London. As few works and no fully signed paintings by Richard are known, *Landscape with Figures* is of particular importance within the history of Irish art.

EB

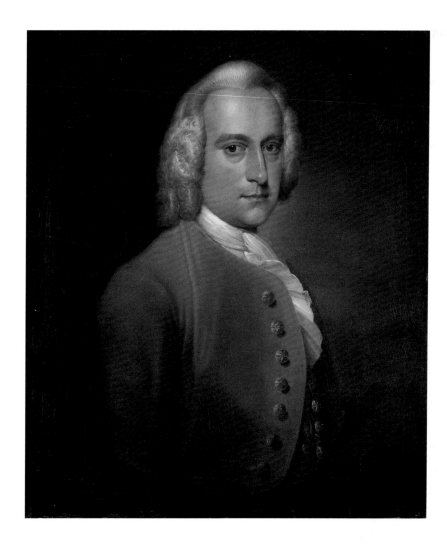

JOHN LEWIS
fl.1736–76

Portrait of an Unknown Man

1748
Oil on canvas
74.8 x 25.8 cm
Signed and dated, bottom right,
Jn Lewis 1748
Purchased 1989
U4752

Details of John Lewis's background are sketchy; however, it appears that he was English, as documentary evidence of 1736 concerning twelve views of north Wales he planned to paint describes him as being from Shrewsbury. He is first recorded in Ireland in 1750, when he became scene painter at Dublin's Smock Alley Theatre. *Portrait of an Unknown Man,* which is of an impressive standard, was therefore probably painted in England. The sitter's thoughtful gaze and intelligent and discerning air make an immediate and forceful impact upon the spectator, so intense and alive is his expression. His attire, an undress jacket and long bob wig (a style of wig worn with undress until at least the 1760s) suggests that he is non-aristocratic and may belong to the merchant class.

Best known as a portraitist, Lewis also worked as a landscape and scene painter. Only a few of his landscapes survive – none painted in Ireland – and nothing of his work for the theatre. During his seven years employed at Smock Alley, he painted a number of Dublin's leading theatrical personalities, including the actress Peg Woffington (National Gallery of Ireland). He maintained his links with Ireland certainly until 1769, when he painted eight members of the Dobbyn family of Waterford.

EB

THOMAS MITCHELL

1735–90

*A View of the River Boyne
with Gentlemen and Horses
by a Statue to William III
in the Foreground, the Boyne
Obelisk beyond*

1757
Oil on canvas
106.8 x 175.5 cm
Signed and dated, lower centre,
T. Mitchell pinxt 1757
Purchased 1990
U4813

This landscape, which is something of an enigma, was painted near the site of Townley Hall, looking south-east towards the river Boyne. Whilst various details are topographically accurate – the Boyne obelisk in the background and the village of Oldbridge to the right – no such statue of King William ever stood on the spot. Modelled on Grinling Gibbons's equestrian statue of the king, situated on College Green, Dublin from 1701 to 1929, the sculpture is clearly the focus of attention of the group of travellers in the foreground. Mitchell's reason for including it can only be guessed at; he may perhaps have been responding to a patron's whim or paying his own personal tribute to the Williamite cause. (As a point of interest, the obelisk was erected in 1736 and taken down in 1922.)

Mitchell, an Englishman, worked as a shipwright for the Admiralty and was also a successful marine painter. *View of the River Boyne* was executed during a visit he paid to Ireland in 1757, as was likewise *A View of Kilkenny* (National Gallery of Ireland). From these, it is clear that he was also a landscape painter of merit. The Ulster Museum painting is decidedly un-Irish in appearance; Mitchell has depicted the Boyne valley as a somewhat idealised landscape, bathed in mellow golden light.

EB

GEORGE BARRET

1728 (or 32)–84

The Waterfall at Powerscourt

c.1762
Oil on canvas
73 x 70 cm
Purchased 1964
U2418

The waterfall at Powerscourt was one of landscape painter George Barret's favourite subjects and he painted it a number of times, from various distances and angles. Four other versions of the picture are known besides that in the Ulster Museum: three in public collections (National Gallery of Ireland, Limerick City Gallery of Art and Walker Art Gallery, Liverpool) and the fourth in a private collection.[2] In painting the waterfall at the far distance shown here, Barret minimises its sublime qualities – its thunderous awe-inspiring power and grandeur – and emphasises instead the picturesque qualities of the overall scene: the woods, golden sky and distant hills. The waterfall, popular with tourists from the 1760s, is the tallest in Ireland, with a drop of 398 feet (116 metres).

Barret's early career in Dublin was marked by fortuitous meetings: with the young philosopher Edmund Burke, who encouraged him to study from nature rather than copy from the Old Masters and also with the 2nd Viscount Powerscourt, who gave him access to his vast demesne in Co. Wicklow. There, he developed his skills in landscape painting before moving to London in 1763. Once established in England, he achieved great success and played a prominent part in the founding of the Royal Academy. He is regarded as one of the forerunners of romantic landscape painting.

EB

GEORGE BARRET

1728 (or 32)–84

Sunset and Ruins

Probably before 1763
Oil on canvas
62.8 x 76.2 cm
Donated by Mrs Aileen Bodkin
in memory of her husband,
Professor Thomas Bodkin, 1974
U2261

Sunset and Ruins is almost certainly an early work by Barret, painted before his departure to London in 1763, a trip necessitated by lack of patronage in Ireland. The dense green foliage and autumnal tints – characteristics which fellow landscape painter Richard Wilson described as eggs and spinach – are typical of his earlier style and can be found in several Powerscourt studies and Wicklow views. In this painting, the ruins, golden evening light and sense of isolation of the two small figures in the boat, combine to create a melancholy and romantic landscape. The scene may be imaginary or perhaps set amongst the Wicklow mountains.

Within a few years of moving to England, Barret was painting in various parts of Britain: Scotland, Wales, the Lake District and the Isle of Wight. Such was his success by the early 1770s that he was reputed to have been earning around £2,000 a year, income which he quickly frittered away through profligacy and carelessness. Highly popular during his lifetime, he was described by fellow painter James Barry – somewhat extravagantly – as 'a superior genius to Claude'. He exhibited regularly at the Royal Academy 1769–82 and at the Society of Artists 1764–68.

EB

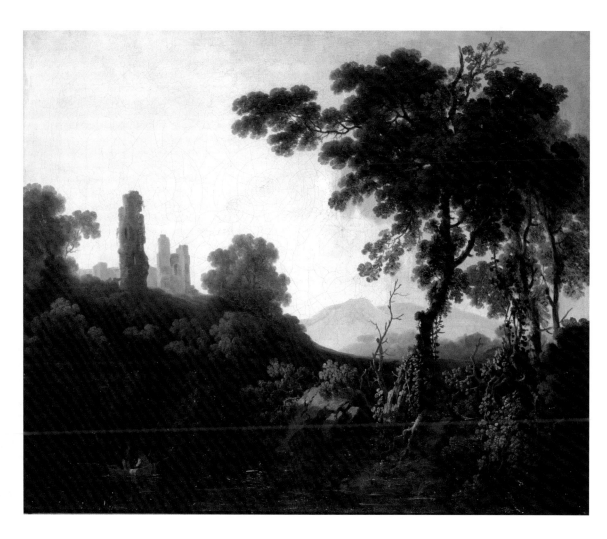

STRICKLAND LOWRY

1737–c.85

The Family of Thomas Bateson,
Esq. (1705–91)

1762
Oil on canvas
163.7 x 264 cm
Dated on harpsichord,
1762
Purchased 1971
U1664

This portrait of the Bateson children is both an imposing conversation piece and a fascinating record of the interior of the Bateson home at Orangefield, Co. Down, near Belfast. Lowry has executed the painting with the eye of a reporter, so detailed and accurate are the children's costumes and the objects in the room. Originally thought to be by Philip Hussey, the current attribution is based upon documentary evidence of 1828 and 1865, which gives the picture to Lowry. Furthermore, the children's large eyes, bland expressions and stiff poses accord with his style. Another portrait attributed to him, that of Thomas Greg and his family of c.1765 (private collection), also displays these characteristics.[3] It, too, shows a room in great detail and was also painted in Belfast. A third work, showing an unidentified family in an interior, is in the National Gallery of Ireland.

A portrait painter from Whitehaven in Cumbria, Lowry arrived in Ireland around 1762 and worked in the country intermittently until the early 1780s, mainly in the north, though details of his movements are sketchy. Besides portraits, his output embraced still-life and *trompe l'oeil* paintings, works which show him to have been a versatile and clever painter. His scenes of families in domestic settings are particularly valuable, as few eighteenth-century Irish paintings depicting contemporary interiors are known.

EB

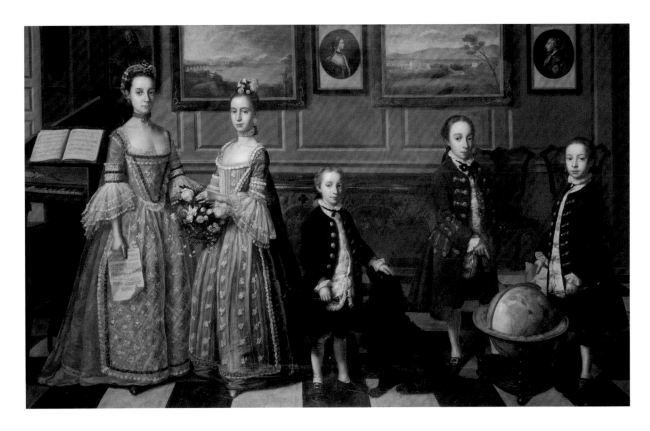

NATHANIEL HONE

1718–84

Portrait of his Son Sketching

c.1769
Oil on canvas
63.5 x 76 cm
Purchased 1969
U228

Hone was the father of a large family and painted at least two of his children – Horace (1756–1825) and John Camillus (1759–1836) – a number of times. This portrait almost certainly shows the latter aged about ten, *porte-crayon* in hand, engrossed in his sketching. The work is an interesting contrast to another portrait of him, *A Piping Boy – John Camillus Hone* of 1769 (National Gallery of Ireland), which depicts him dressed as a shepherd boy. Camillus seems to have been his father's favourite model, as other portraits are also known of him. Horace, as fair as Camillus was dark, is also the subject of a work in the National Gallery of Ireland: *Portrait of a Boy (Horace Hone) Sketching* of c.1766. This was probably the portrait Hone exhibited at the Society of Artists, London in 1766 as *A Boy deliberating on his Drawing*. Both Horace and John Camillus became painters.

Hone left Dublin for England probably in the late 1730s and settled in London, where he established a successful portrait practice. Though he was chiefly influenced by Dutch art, he did, at times, acknowledge the value of Renaissance sources, by occasionally including classical motifs in his work. *Portrait of his Son Sketching* is particularly interesting in that it pays tribute to both sources, by the inclusion of the landscape by Jan van Goyen and the small bronze statuette of Victory after the antique being sketched by Camillus.

EB

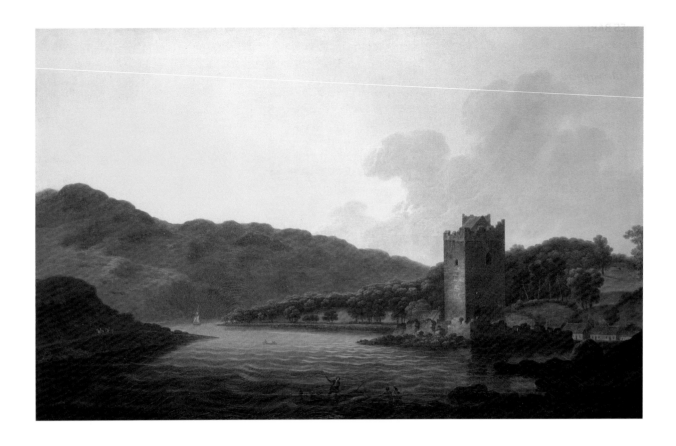

JONATHAN FISHER
d.1809

*View of the Ferry and Castle
of Narrow Water*

c.1771
Oil on canvas
80.6 x 127 cm
Purchased 1969
U659

This is one of a series of six oil paintings of the Carlingford area which Fisher published as engravings in 1772. (The whereabouts of the five other paintings are unknown). Dominating the view is Narrow Water Castle, built around 1560, whilst behind it is the demesne of Roger Hall, High Sheriff of counties Down and Armagh. The work transcends straightforward topographical recording by the inclusion of poetic touches like the mellow golden light and atmospheric sky, elements which lend a romantic aura to the scene. The knobbly-looking trees and strong green are characteristic of Fisher's style. There is an attractive naïve quality to the picture.

Fisher travelled widely throughout Ireland and did much to popularise the scenery of the country by the engravings and aquatints he published of his landscapes. His most important venture of the type was the publication of a volume of sixty views in 1796, the first comprehensive survey of the scenery of Ireland. A number of sets of his original paintings are extant, including scenes of Castleward and Strangford Lough (Castleward, National Trust), Castledillon, Co. Armagh (Armagh County Museum) and Belvoir, near Belfast (private collection)[4]. These last are particularly interesting as few landscapes of Belfast's environs of the second half of the eighteenth century are known.

EB

JAMES BARRY

1741–1806

Venus Rising from the Sea

c.1772
Oil on canvas
75 x 55 cm
Donated by Mrs Aileen Bodkin
in memory of her husband,
Professor Thomas Bodkin, 1963
U14

This work is a study for the much larger *Venus Rising from the Sea* exhibited at the Royal Academy in London in 1772 (Dublin City Gallery The Hugh Lane). Recently returned from Italy, Barry sought to display his classical erudition and knowledge of antique sculpture by painting in the grand manner. The Greek author Hesiod had described how Venus was born from the waves breaking on the shores of Cyprus. Apelles, the greatest artist of antiquity, painted a famous *Venus Rising from the Sea,* known to Barry only through literary description. In choosing to paint the same subject Barry intended his skill to be compared with that of Apelles.

Born in Cork, Barry showed early promise as a draughtsman and in 1760 enrolled in the Dublin Society's Drawing Schools. His talent attracted the patronage of Edmund Burke, who provided funds for him to study in Italy. He arrived in Rome in 1766 and over the next five years developed a fluid and refined drawing style based on his study of the antique and later Italian art. *Venus Rising from the Sea* depicts the moment of the goddess's birth. Great shafts of light illuminate the sky as Venus raises her long hair, wet from the sea, high above her head in a gesture of graceful triumph.

AS

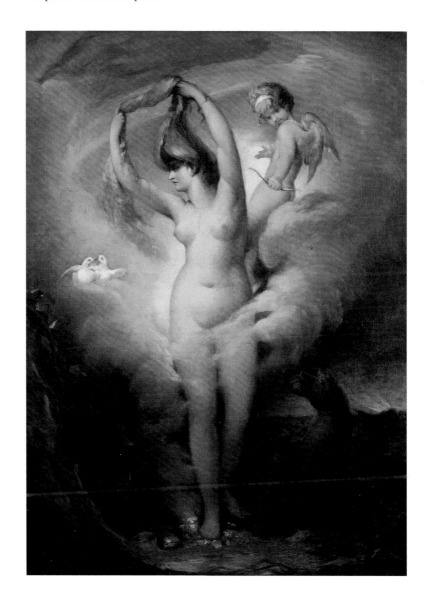

JOSEPH WILSON

fl. c.1766–89, d. 1793

William Dawson (1759–1834)

1778
Oil on canvas
76.5 x 63.6 cm
Bequeathed by Richard Baxter,
Belfast, 1922
U176

This portrait of William Dawson is said to have been painted in 1778, when he was aged nineteen and to show him in Volunteer uniform. However, whilst he is known to have been in the Grenadier division of the Belfast 1st Volunteer Company, founded on 17 March 1778, he appears to be wearing civilian rather than military dress; there are no ornamental trimmings on his coat other than the collar button. Nevertheless, his impressive cockaded hat lends a definite military air to his appearance. According to his burial notice in the records of the Belfast Charitable Society, he was a gentleman, that is, a person of independent means and resided in east Belfast.

Portrait painter Joseph Wilson worked in Belfast from the 1760s to the 1780s, his sitters coming mainly from the professional and merchant classes. He also painted a number of Volunteers and may have been one himself; the Belfast historian George Benn records a Joseph Wilson as belonging to the Belfast 1st Volunteer Company at the same time as Dawson. Less gifted than Strickland Lowry, his main competitor in Belfast at the time, his works are characterised by stiff poses and lack of animation. The portrait of Dawson is unquestionably his masterpiece, in the naturalistic appearance of the sitter and the impression of personality conveyed.

EB

FRANCIS WHEATLEY

1747–1801

John O'Neill, 1st Viscount O'Neill of Shane's Castle (1740–98)

c.1780
Oil on canvas
76.5 x 63.6 cm
Purchased 1940
U146

Some of Wheatley's best works were painted during his Irish sojourn of 1779–83, his most famous being his group portrait of 148 members of the Irish House of Commons of 1780.[5] Amongst those present was Lord O'Neill. This delicately executed head and shoulders may be related to the Commons picture or was perhaps commissioned because of it. O'Neill, MP for Randalstown, Co. Antrim 1761–83 and for Co. Antrim 1783–93, served as colonel of the Antrim Regiment of Militia during the 1798 rebellion and died of wounds received in a skirmish with United Irish forces at Antrim.

Wheatley's above-mentioned visit was occasioned by a flight from his creditors in London. His stay coincided with the heyday of the Volunteer movement, a part-time military force established in Belfast in 1778 to defend Ireland against the French, regular troops having been removed to fight in the American Revolution. Volunteer companies were subsequently established throughout Ireland, with the majority of Volunteers being from Ulster. Wheatley painted a number of Volunteer groups, his best known being *The Dublin Volunteers in College Green, 4th November, 1779* (National Gallery of Ireland). His paintings of this period in Irish history are of immense value to posterity.

EB

WILLIAM ASHFORD

1746–1824

*Landscape with Carriage
and Horses*

Possibly c.1781
Oil on canvas
72 x 89 cm
Signed on carriage,
W. Ashford
Purchased 1975
U2295

Uncertainty surrounds the identity of this scene. Though the work was purchased as being a view of Howth Castle, near Dublin, this has proved not to be the case. An almost identical version of the picture, dated 1781 and entitled *A Carriage passing Frascati,* is at Carton, Co. Kildare.[6] This identity, too, has been dismissed. Nonetheless, as most of Ashford's work was straightforwardly topographical, the scene almost certainly represents an actual place, perhaps the family seat of the passengers in the carriage. The painting verges on the picturesque, in the trees, brook and glowing sunlit sky.

Born in Birmingham, Ashford moved to Ireland in 1764, to work for the Ordnance Office in Dublin and appears to have been self-taught as an artist. He began exhibiting landscapes in 1772 and became in time Ireland's foremost exponent of the genre, being elected first President of the Royal Hibernian Academy in 1823 – a signal honour for a landscape painter. Most of his works were topographical views of country seats and well-ordered parks for the nobility and gentry and he rarely painted untamed nature. Despite his long residence in Ireland, his landscapes retain a distinctly English air, a characteristic clearly discernible in *Landscape with Carriage and Horses*.

EB

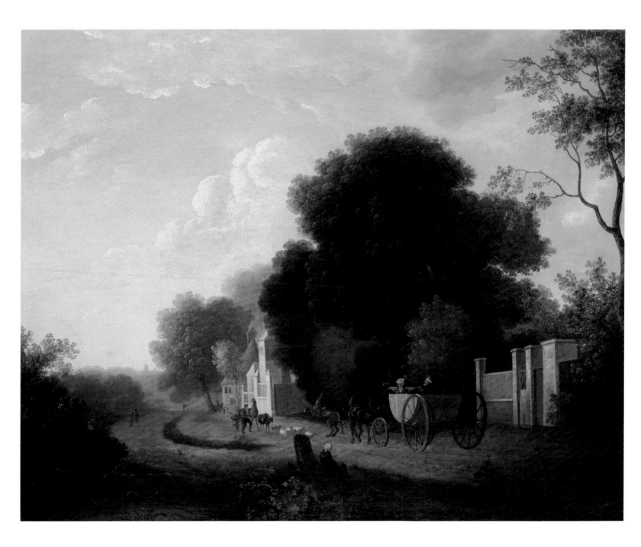

HUGH DOUGLAS HAMILTON

1740–1808

Colonel Hugh O'Donnell (d.1799)

c.1795–96
Oil on canvas
76.2 x 63.3 cm
Donated by representatives of
Sir Francis and Lady Stronge,
per the Rt. Hon. Sir James H.
Stronge, Tynan Abbey, Co.
Armagh, 1925
U51

This portrait is one of a pair by Hamilton of the O'Donnell brothers of Newport House, Co. Mayo, the other being of the sitter's younger brother, James Moore O'Donnell (also Ulster Museum). Both works are head and shoulders size, within feigned ovals. The portrait, set against a dark background to give greater emphasis to the sitter's features, is delicately executed, with considerable attention paid to expression and character. O'Donnell was MP for the borough of Donegal between 1798 and 1799 and was strongly opposed to the legislative union of Ireland and Britain, brought about through the Act of Union of 1800. He was dismissed from the army in 1799 because of his political beliefs.

Hamilton's first success was as a pastellist, initially in Dublin and thereafter in London. Between 1782 and 1792 he was in Italy, where he began to work more in oils and where his sitters included numerous Grand Tourists. (O'Donnell himself may have been one, as Hamilton painted him standing full-length in a sculpture gallery, probably in Rome in 1791; private collection).[7] He returned to Dublin in 1792 and continued to work in both media until 1794, when he abandoned pastel entirely. Many prominent figures in Irish public life sat to him.

EB

THOMAS ROBINSON

d. 1810

William Ritchie (1756–1834)

c.1802
Oil on canvas
93.7 x 74.6 cm
Donated by Alexander MacLaine,
Belfast, 1892
U144

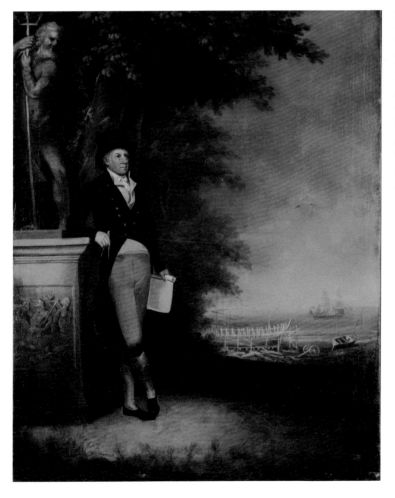

Symbolism abounds in this portrait of shipbuilder William Ritchie, in the inclusion of the statue of Neptune, god of the sea and in the depiction of the small shipyard, the mark of Ritchie's livelihood. A Scot from Ayrshire, Ritchie established the first shipyard in Belfast in 1791 and also constructed the first dry dock for the Ballast Board (the forerunner of the Belfast Harbour Commissioners) between 1796 and 1800. Adopting the cross-legged pose of fashionable portraiture, compasses and paper in hand, he seems the epitome of the confident, self-made man. Ritchie and Robinson were firm friends.

A portrait and landscape painter from Windermere, Robinson settled in Dublin in 1790. In 1793 he moved north, firstly to Lawrencetown, Co. Down, then to Lisburn by 1798 and eventually to Belfast, in 1801. Whilst in the north, he built up an extensive portrait practice and also executed two history pieces which have since become extremely well known: *The Battle of Ballynahinch* of 1798 (Office of Public Works, Dublin) and *Review of the Belfast Yeomanry by the Lord Lieutenant, the Earl of Hardwicke, 27 August 1804* (Belfast Harbour Commissioners). This latter includes numerous local persons from the upper and middle classes and is a fascinating glimpse of Belfast society. Though Robinson's style is somewhat awkward and provincial, his works have considerable worth as social and historical records.

EB

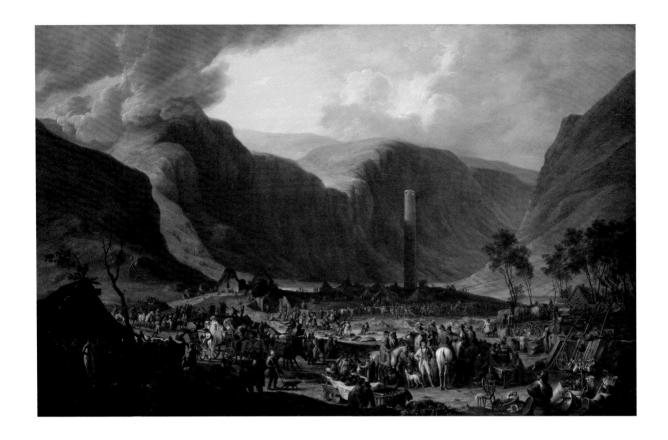

JOSEPH PEACOCK
c.1783–1837

*The Patron, or Festival of St
Kevin at the Seven Churches,
Glendalough*

1813
Oil on panel
86.4 x 137.8 cm
Signed and dated, mid-left,
J. Peacock Pinxit 1813
Purchased 1964
U120

This work shows the festivities surrounding
the feast day of St Kevin, held annually on 3
June at Glendalough, Co. Wicklow, where Kevin
had founded a monastery in the sixth century.
Though patrons (or patterns) were intended to
have a devotional character, no such religious
sentiment can be detected here. Instead, the
scene is one of merriment and worldliness:
dancing, drinking and the trading of goods.
There is also a faction fight taking place near
the round tower. This particular pattern was
suppressed by Cardinal Cullen in 1862, as part
of a move by the Catholic clergy to prohibit
local festivals which had become occasions
for drunkenness and debauchery.

Peacock, who described himself as a 'Familiar
Life and Animal Painter', made his reputation
with crowd scenes like this and depictions of
events such as Donnybrook and Palmerston
Fairs. Though few works by him are extant,
he was clearly gifted, with a closely observed
technique and a keen eye for detail. He also had
a feeling for the theatrical: in this work he has
exaggerated the height of the round tower and
the mountains, to add a sense of drama to the
scene. The painting is a fascinating glimpse of
Irish life in the early nineteenth century.

EB

JAMES ARTHUR O'CONNOR

1792–1841

Scene in Co. Wicklow

1820
Oil on canvas
70.8 x 91.3 cm
Signed and dated, bottom left,
J.A. O'Connor 1820
Purchased 1970
U680

O'Connor's landscapes exhibit a variety of styles, passing from the topographical, through the picturesque, to the brooding romanticism of his later period from c.1830. *Scene in Co. Wicklow* dates from his picturesque period and is Claudean in composition, namely, dark foreground colours changing into light as the eye moves to the far background. The work was painted near Kilcroney, some 1½ miles south-west of Bray, Co. Wicklow, with the Great Sugar Loaf and Little Sugar Loaf mountains in the background. The river meandering under the bridge is the Dargle. Such is the idealised treatment of the landscape and peasantry (the splash of red in the clothing is a frequent motif of O'Connor's), the scene could be set in some rustic Arcadia and not amongst the mountains and valleys of Wicklow.

O'Connor showed regularly in Dublin between 1809 and 1821 and in 1822, settled in London, where he exhibited at the Royal Academy and British Institution. Between 1826 and 1833 he paid visits to Belgium, France and Germany and also returned to Ireland a number of times, to refresh his memory of wild and romantic Irish scenery. He remains one of Ireland's best-known and most popular landscape painters.

EB

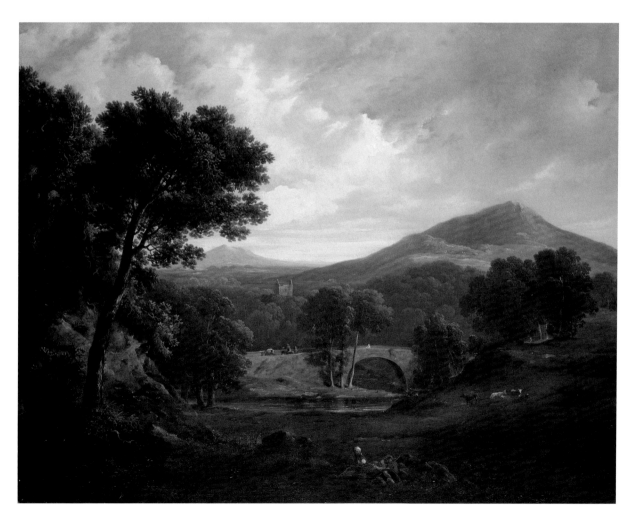

JAMES ARTHUR O'CONNOR

1792–1841

Castle Arras, near Alf,
on the Moselle

c.1833
Oil on board
22.9 x 28 cm
Signed bottom right,
J. A. O'C
Purchased 1956
U655

O'Connor was on the Continent from September 1832 until October 1833, staying in Paris before moving to Germany in May of the latter year, when he visited the Saar district and various towns on the river Moselle. This little picture was therefore probably painted between May and October 1833. The scene, which shows a small isolated figure in a still, mountainous landscape at sunset (or sunrise), is typical of the Romanticism of O'Connor's late work.

O'Connor's images of Romantic isolation sometimes took the form of a solitary monk in a rocky valley by a river, of which he is known to have painted at least two versions (private collections).[8] The theme can be traced from Salvator Rosa, through Richard Wilson's *Solitude* of 1762 (National Gallery of Ireland) to Caspar David Friedrich's *Monk by the Sea* of 1810 (Schloss Charlottenburg, Berlin), probably the most powerful visualization of the idea. Castle Arras was erected in 938 AD by the Bishop of Trier. The sense of quietness which pervades much of O'Connor's work is very marked in the picture.

EB

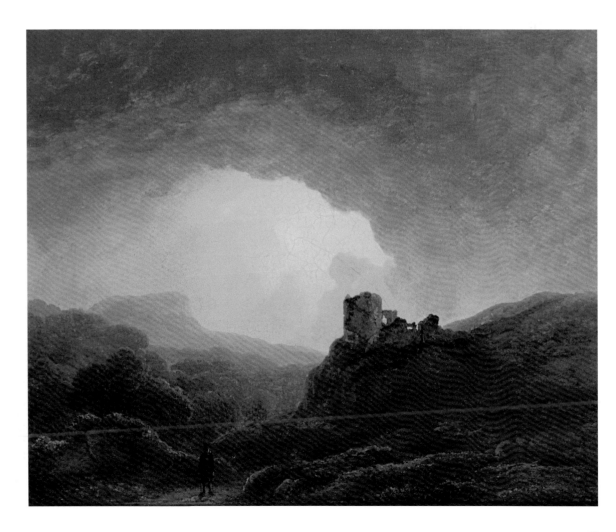

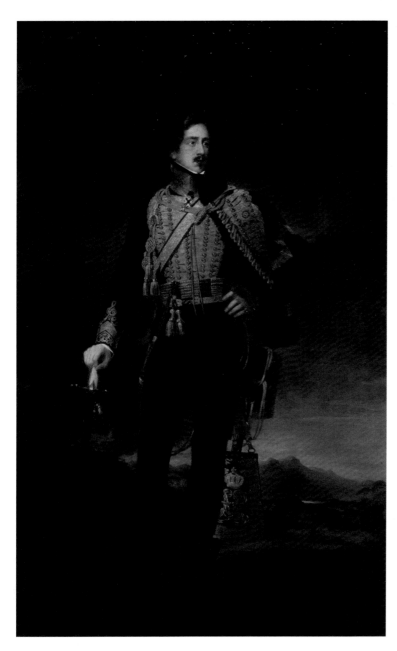

JAMES ATKINS
1799–1833

*George Hamilton, 3rd Marquess
of Donegall (1797–1883)*

1824
Oil on canvas
233.7 x 145.4 cm
Signed and dated, bottom left,
James Atkins Rome 1824
Purchased 1980
U2570

This dashing portrait of the twenty-seven-year-old Marquess of Donegall shows him in a brooding and romantic landscape, attired in the uniform of a captain of the 7th Hussars, a regiment he was associated with between 1819 and 1829. He subsequently served with the Yeomen of the Guard and with the Royal Irish Rifle Volunteers. Besides his military pursuits, he had an active political career 1818–38 and also held a number of official offices. The painting, which echoes Sir Thomas Lawrence in style and atmosphere, is an impressive testimony to Atkins's skill. Donegall possibly commissioned the work because his mother, the 2nd Marchioness of Donegall, had been one of Atkins's early patrons.

Atkins attended the drawing school of the Belfast Academical Institution and was an outstanding pupil. In 1819 a group of local nobility and gentry raised a subscription to send him to Italy to further his studies. He remained there until 1832, when he left Rome for Constantinople to paint the Sultan. His health failing, he travelled to Malta in hope of recovery but died in Valetta in 1833. The contents of his studio in Rome were returned to Belfast in 1834 and exhibited in Donegall Place, the first large-scale one-man show to be held in town. A gifted and versatile painter, his early death was deeply mourned by many local patrons of the arts.

EB

WILLIAM SADLER II

c.1782–1839

The Eagle's Nest, Killarney

Oil on panel
48.5 x 80 cm
Purchased 1969
U227

Killarney became popular with tourists during the 1750s. Seen here is the Eagle's Nest, a mountain situated by the Upper Lake. This particular spot was always used as an 'echo station' for travellers making the trip from the Upper Lake to Muckross Lake, the echoes produced here being considered the best in Killarney. To that end, canon were fired and bugles blown for visitors eager to experience the awe-inspiring grandeur of the sounds. Both canon and bugler can be seen to the left of the picture. Sadler painted at least two other versions of the subject: one exhibited in *Irish Houses and Landscapes* (53), the other auctioned at Christie's, London, 26 March 1976, lot 128.

A Dublin painter, Sadler's output comprised landscapes, mainly of Dublin and surrounds, scenes of journalistic interest, battle scenes and conflagrations. The bulk of his work is on small wooden panels but his acknowledged masterpiece – the *Battle of Waterloo* (private collection) – is larger and on canvas.[9] From this, it is clear that he was more gifted than had been supposed. His landscapes are distinguished by smooth skies and thick, lumped paint in the vegetation, traits obvious in this picture.

EB

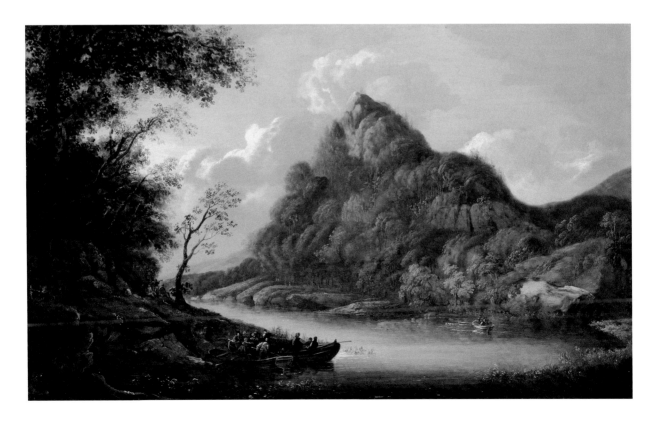

MARTIN CREGAN

1788–1870

Francis Johnston (1760–1829),
his Wife and Two Nephews

c.1827
Oil on canvas
97.7 x 80.3 cm
Purchased 1971
U731

An intimate and touching image of family life, the portrait shows the architect Francis Johnston, his wife Anne and their two nephews, Andrew (the taller boy) and Robert, relaxing in a drawing room. (The couple had no children of their own.) The inclusion of a pet dog and toys on the floor lend an air of domesticity and cosiness to the scene. Johnston had a busy and successful practice; amongst the buildings he designed were the Chapel Royal, Dublin Castle (1807–14) and the General Post Office, Dublin (1814–18). A great patron of the arts, he was President of the Royal Hibernian Academy from 1824 to 1829 and erected the Academy's first premises in Abbey Street, at his own expense. The folder of drawings on the easel and the bust on the mantelpiece are symbols of his profession and interests.

Portrait painter Martin Cregan, who came from Co. Meath, was raised by foster-parents called Creggan, whose name he took and later altered. After a period of study in London, he returned to Dublin, where he became highly successful. Extremely prolific, he exhibited at the Royal Hibernian Academy between 1826 and 1859 and was its President from 1832 to 1857. He was also portrait painter to the Lord Lieutenant of Ireland. This is one of his most successful portraits.

EB

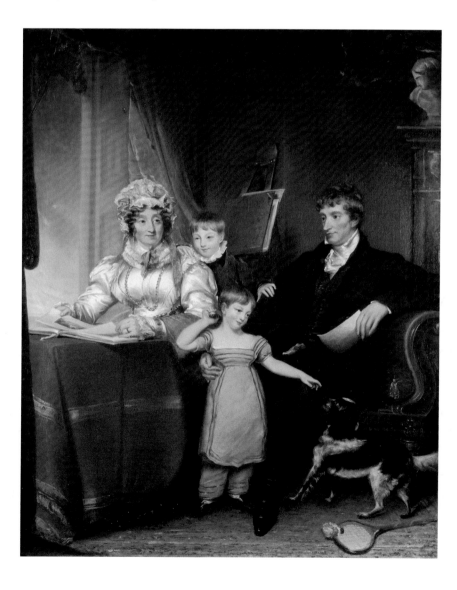

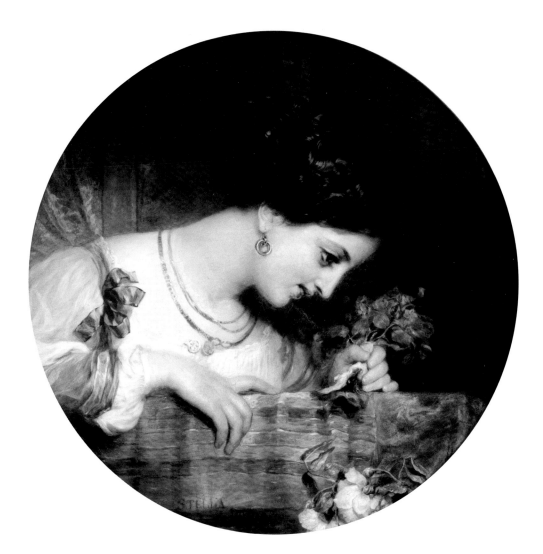

RICHARD ROTHWELL
1800–68

Stella in Rome

Probably 1831–34
Oil on canvas
65.3 x 65.3 cm
Signed bottom centre,
Stella in Rome R. Rothwell
Donated by the Misses R.
and F. F. Patterson and
Mr R. R. Patterson, 1943
(the Rothwell Bequest)
U152

The identity of this pretty young woman is unknown but as the picture was probably painted during Rothwell's first sojourn in Italy between 1831 and 1834, she is possibly Italian; her lustrous dark hair, hooped earrings and peasant-style blouse would indicate this. The work is very delicately executed; the sitter's skin seems to glow and the treatment of the flowers is extremely naturalistic. An identical version of the picture but with the title written in Italian, is in a private collection in Dublin. The painting is circular in format but on a square canvas.

Portrait and subject painter Richard Rothwell achieved great success in Dublin and London by 1831, when he went to Italy to study the Old Masters. Returning to London three years later, he found his position as a leading portrait painter filled by others, a situation which embittered him for the rest of his career. A restless and temperamental individual, he spent the years from 1847 moving between Ireland, London, America, Paris, Brussels and Rome. Though his early career promised a brilliant future, he never found the success he craved. His wife was from Belfast and he spent periods in the town. His sitters included a number of well-known local figures.

EB

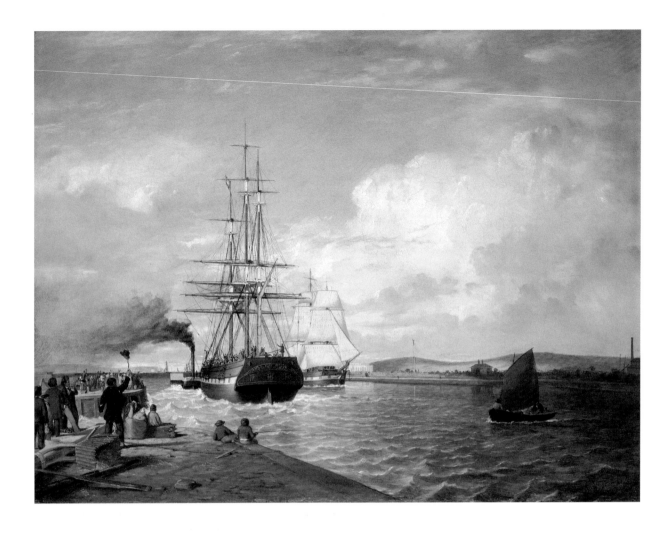

JAMES GLEN WILSON
1827–63

Emigrant Ship leaving Belfast

1852
Oil on canvas
71.4 x 91.3 cm
Signed and dated, bottom left,
J. Glen Wilson 1852
Purchased 1953
U178

Although emigration was a major part of Irish life, few images of emigrant ships are known; this Belfast view and *An Emigrant Ship, Dublin Bay, Sunset* by Edwin Hayes (National Gallery of Ireland) are the best-known representations of the subject. The scene shows a departing ship, probably bound for America, being towed down the Victoria Channel, towards the open sea. In the right background is the Queen's Island, future site of the world-famous shipbuilding firm of Harland and Wolff. The painting reveals Wilson's mastery of natural elements like sea and sky and his eye for genre detail, seen in the grief-stricken families at the quayside, waving their loved ones off to far-away shores.

An enigmatic figure in the art history of the north of Ireland, Wilson came from Co. Down and may have studied in Belfast. Almost nothing is known of his life until March 1852, when he joined the Royal Navy as a ship's artist. Thereafter, he spent seven years at sea before settling in Australia, where he worked as a surveyor for the New South Wales Department of Lands. Large numbers of his paintings and drawings, produced during his sea-going travels, are in public and private collections in England and Australia.

EB

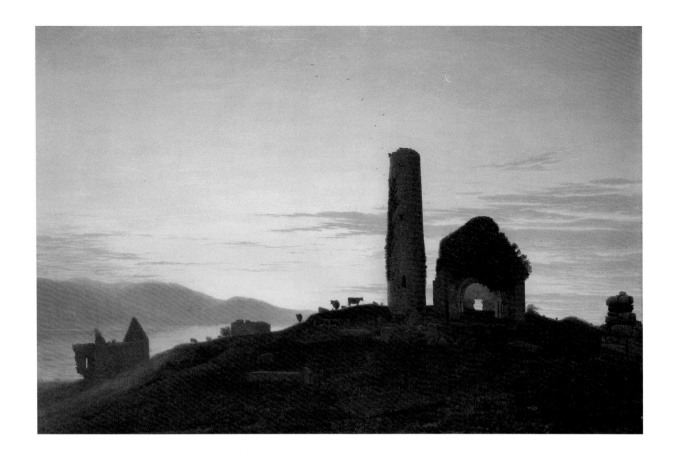

BARTHOLOMEW COLLES WATKINS

1833–91

Ecclesiastical Ruins on Inniscaltra, or Holy Island, Lough Derg, Co. Galway, after Sunset: "This Island is One of Great Historic Interest ..." – Petrie

c.1863
Oil on canvas
104.3 x 153 cm
Signed bottom right,
B. Colles Watkins RHA
Purchased 1968
U124

Inniscaltra, also called Holy Island, is one mile south-east of the village of Mountshannon, in the stretch of Lough Derg which is situated in Co. Clare (and not in Co. Galway, as stated in the title). The monastery on the island was founded by St Caimin in the seventh century but was burned by the Vikings in 836 and 922 AD; however, St Caimin's church continued in use until the fourteenth century. Buildings remaining include five churches, an anchorite's cell and a round tower. Those in the picture are readily identifiable and are, from left to right, St Mary's church, St Brigid's church, the round tower, St Caimin's church and the anchorite's cell. The gravestone in the mid-foreground is no longer there, having been moved to Adare Manor, Co. Limerick by Edwin, 3rd Earl of Dunraven, sometime between c.1863 and 1871.

A somewhat neglected artist today, Watkins specialised in Irish mountain scenery, such as in the Killarney area and monastic ruins and castles in various parts of the country. His works are simply and realistically executed, with a strong feeling for light, as in the magnificent sunset effects of this painting. The work was shown at the Royal Hibernian Academy in 1866, as was another version of the picture, the whereabouts of which is unknown.

EB

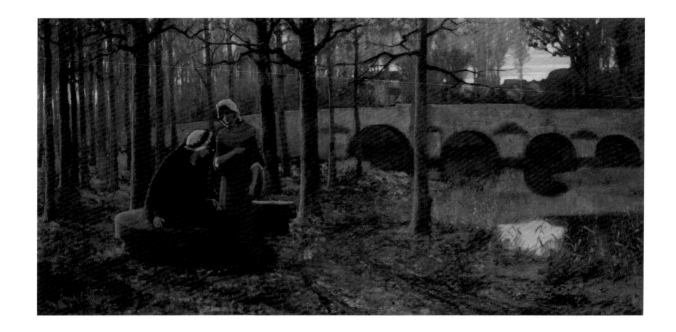

FRANK O'MEARA

1853–88

Autumnal Sorrows

1878
Oil on canvas
48.5 x 99.8 cm
Signed and dated, bottom left,
Frank O'Meara 1878
Purchased 1980
U2556

Autumnal Sorrows was painted at Grez-sur-Loing, a small village in the Forest of Fontainebleau south of Paris, popular with artists in the late nineteenth century. The picturesque bridge over the river Loing, painted by a number of artists including John Lavery, can be seen in the background, its arches reflected in the still water. Executed in autumnal tones of green and russet, the painting contains motifs characteristic of O'Meara's work in his later years: women seen near water's edge, bare trees, dull autumn light and overall, a feeling of sadness and melancholy. The village itself appears to have had a melancholic feeling, according to the writer Robert Louis Stevenson, who visited in 1875 and described the atmosphere of the place as one of sadness and slackness.

One of the foremost Irish exponents of *plein-air* painting, that is, painting in the open air, O'Meara studied in Paris and spent the years between 1875 and 1887 mostly at Grez, producing works of a haunting and poetic quality; lonely women in landscapes, executed in his characteristic palette of pale greys, grey-greens and russet, with sombre titles such as *The Widow, Towards Night and Winter* and *October*. Many of these were painted in an evening or autumnal light, his preferred time and season. A dreamy, lyrical feeling pervades his art.

EB

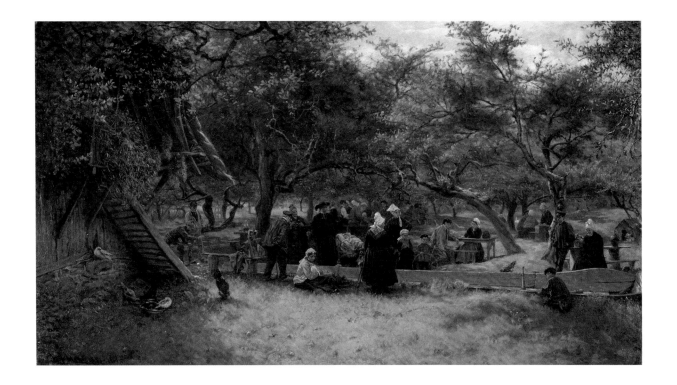

WILLIAM JOHN HENNESSY
1839–1917

Fête Day in a Cider Orchard, Normandy

1878
Oil on canvas
99 x 178 cm
Signed and dated, bottom left,
W.J. Hennessy 1878
Purchased 1987
U4708

Scenes of peasant life in Normandy and Brittany were popular subjects with French, British and Irish artists from the 1870s. This picture shows villagers playing *quilles*, a form of skittles popular in Normandy. In the background, groups of people sit under the trees, enjoying the day. Hennessy depicts the scene in the sun-dappled orchard with considerable detail: the costume of the villagers, the twisted branches of the trees, the apples lying forgotten on the grass. The painting almost smells of the open air, so immediate and fresh are the effects of sunlight and shade.

Hennessy began spending summers in Normandy and Brittany in 1875, painting scenes of peasant life and fisherfolk *en plein-air*. Whilst such a large work as the *Fête Day* was probably painted in the studio, from studies made outdoors, the picture is certainly imbued with an open-air feeling. The work was exhibited at the Grosvenor Gallery, London (a prestigious venue for avant-garde art) in 1878, together with works by other artists specialising in scenes of rustic naturalism. An Irish-American who settled in England in 1870, Hennessy's work, though highly regarded in the late nineteenth century, is little known in Ireland today.

EB

SIR JOHN LAVERY

1856–1941

Under the Cherry Tree

1884
Oil on canvas
150.8 x 150.4 cm
Signed and dated,
bottom centre right,
J. Lavery 1884
Donated by the artist, 1929
U67

Born in Belfast, Lavery began his artistic training in Glasgow. During the early 1880s he studied in Paris and made visits to the artists' colony at Grez-sur-Loing, near Fontainebleau. At Grez, Lavery was one of many young artists to set up their easels in the fields around the picturesque village and work *en plein-air*, a term used to describe painting in the open air. Originally called *On the Loing; An Afternoon Chat*, the painting now known as *Under the Cherry Tree* is larger and more ambitious than any Lavery had previously attempted. It is a youthful masterwork, heavily influenced by Bastien-Lepage and was intended to display the painterly techniques he had recently acquired through study in France.

The composition of *Under the Cherry Tree* is divided into three distinct areas and Lavery employed a different technique in the painting of each. The foreground vegetation is thickly painted with tall plants and fallen stalks creating a framework for the tiny brightly coloured wild flowers. The figures are modelled with confident squared brushstrokes and, although set widely apart, their easy intimacy anticipates Lavery's later portrait groups. The bridge and slowly flowing river are thinly painted with light brushstrokes heightening the gentle, languorous quality of the work.

AS

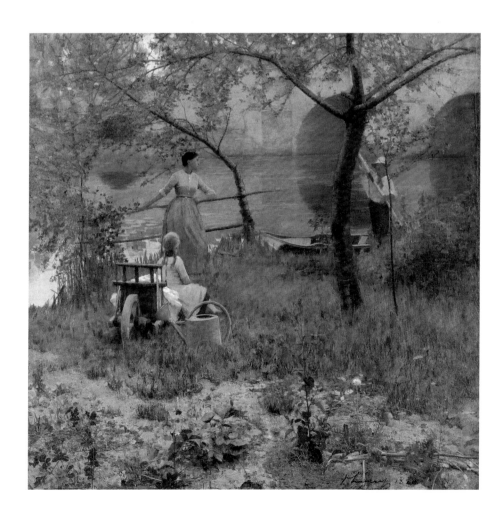

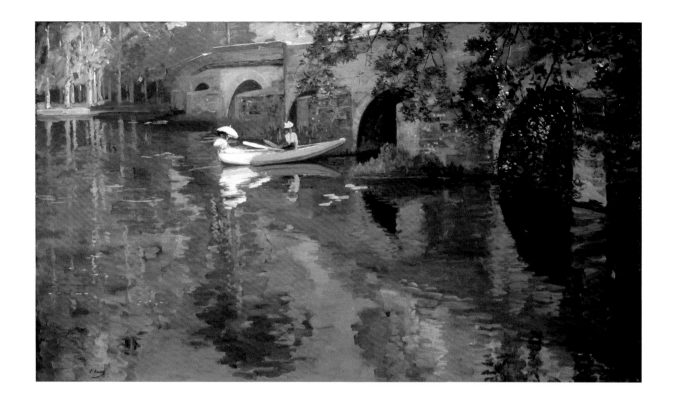

SIR JOHN LAVERY

1856–1941

The Bridge at Grès

c.1897
Oil on canvas
89.1 x 148.3cm
Signed bottom left,
J. Lavery
Donated by the artist, 1929
U60

Soon after completing *Under the Cherry Tree*, Lavery returned to Glasgow, where he quickly established a reputation as a leading portraitist. Four years later, in 1888, he painted *The State Visit of Queen Victoria to the Glasgow International Exhibition*, a commission which introduced him to fashionable society and later enabled him to settle in London. During the 1890s Lavery travelled extensively and spent long periods in Tangier, where he tirelessly painted the exotic light and architecture and developed his remarkable ability to create mood in his landscape painting.

Late in the 1890s, Lavery returned to France and revisited Grez in 1897 and 1900. In *The Bridge at Grès* (Lavery used the traditional spelling), he adopted a similar view to his early masterwork, although by this date his technique had become more fluid and reveals the influence of both Whistler and Sargent. The work was painted quickly, almost in a single session and is one of the finest examples of Lavery's increasingly sophisticated landscape painting, capturing atmosphere through the use of spontaneous brushwork. The horizon line is set high in the painting and the figures only sketchily observed. The real subject of the painting is the river surface, which recalls Monet's fascination with the effects of light on water.

AS

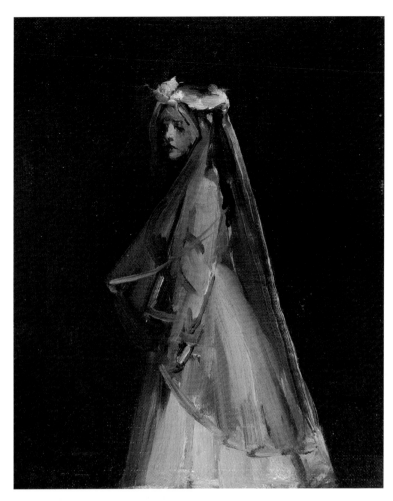

SIR JOHN LAVERY
1856–1941

Eileen, Her First Communion

1901
Oil on board
25.2 x 20.8 cm
Signed and dated, bottom right,
Eileen 1901 J. Lavery
Donated by the artist, 1929
U80

By the early 1890s Lavery had become the leading portraitist of the Glasgow School. The appeal of his elegant and accomplished style was, in part, the result of his study of Velázquez and the persuasive influence of Whistler. In 1896 Lavery moved to London and became drawn into Whistler's circle, enabling him to observe and study the older artist's techniques at first hand. A cautious friendship developed between the two artists and Lavery increasingly adopted Whistler's use of colour harmonies based on muted shades of white and grey.

Eileen was Lavery's only child, the daughter of his first wife Kathleen who had died soon after her daughter's birth. Eileen was seven and on holiday from her convent boarding school when she was painted by her father in her First Communion dress. The economy of colour and detail is impressive, as is the solemnity of the young girl whose grave presence is defined in a few rapid, assured brushstrokes. Early in his career Lavery had started to use small oil sketches to work out the composition and tonality of his large scale works. *Eileen, Her First Communion* is a preparatory sketch for a full-length portrait that, in its muted colour range and references to Velázquez's Infantas, was Lavery's homage to Whistler.

AS

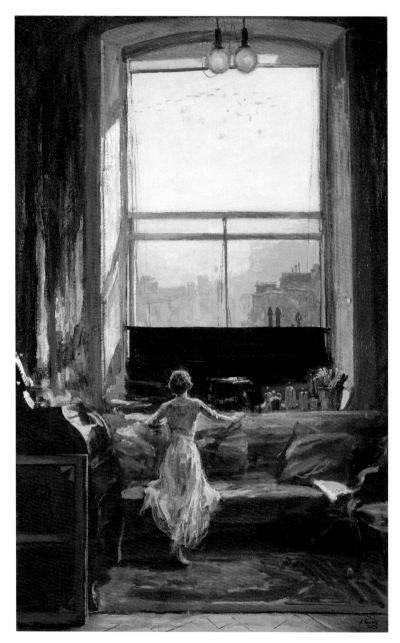

SIR JOHN LAVERY
1856–1941

Daylight Raid from my Studio
Window, 7th July 1917

1917
Oil on canvas
141.5 x 89.9 cm
Signed bottom right,
J. Lavery;
dated on reverse
Donated by the artist, 1929
U71

Daylight Raid from my Studio Window records
the afternoon of 7 July 1917, when German
Gotha biplanes appeared in the skies above
London and were engaged by the Royal
Naval Air Service and the Royal Flying Corps.
The ensuing dogfight was clearly visible
from the large window of Lavery's studio in
Kensington and is watched by the artist's wife
Hazel, her head outlined against a blackout
curtain. Lavery was particularly adept at
recording large gatherings and events by
making rapid impressionistic oil sketches.
Here he uses quick fluid brushstrokes to describe
the disorderly clutter of his spacious studio
and the menacing presence of the tiny planes
in the clear sky beyond.

Lavery was an official war artist attached to
the Royal Navy during the Great War. Although
he did not see action, his war paintings reveal
much about the anxiety of civilian life in London
and the country. Lavery was fascinated by the
curious beauty and dramatic possibilities of the
new war in the air and made many studies of
aircraft. He was probably the first artist to paint
from the air, working from an airship above
a convoy in the North Sea in 1918.

AS

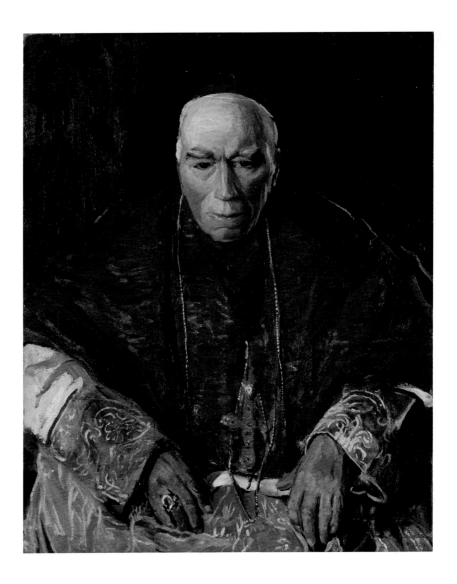

SIR JOHN LAVERY

1856–1941

Cardinal Logue (1840–1924)

1920
Oil on canvas
79.1 x 64.1 cm
Signed top left,
J. Lavery;
dated on reverse
Donated by the artist, 1929
U64

Cardinal Logue was born at Carrigart, Co. Donegal and became Archbishop of Armagh in 1887. A keen Irish speaker and supporter of the Gaelic League, the Cardinal was eighty when he sat for this portrait. The astute determination of his personality is at once apparent, making this one of Lavery's most penetrating and memorable portraits. By the 1920s Lavery had adopted a more forceful painterly style, using brighter colours and a looser technique. *Cardinal Logue* is an early example of the new vividness that characterises his later portraits.

Although born in Belfast, Lavery had very little contact with his native city until his friendship with Sir Hugh Lane drew him into Irish artistic life and politics. Lavery's second wife Hazel was of Irish descent and the couple followed political events in Ireland closely. At the time of the Treaty negotiations their friendships with Winston Churchill and Michael Collins enabled the two sides to meet unofficially at the Laverys' house in London. During this period Lavery sensed that his role in Irish politics was to record events and personalities and he painted a series of portraits of prominent figures of which *Cardinal Logue* is one of the most impressive.

AS

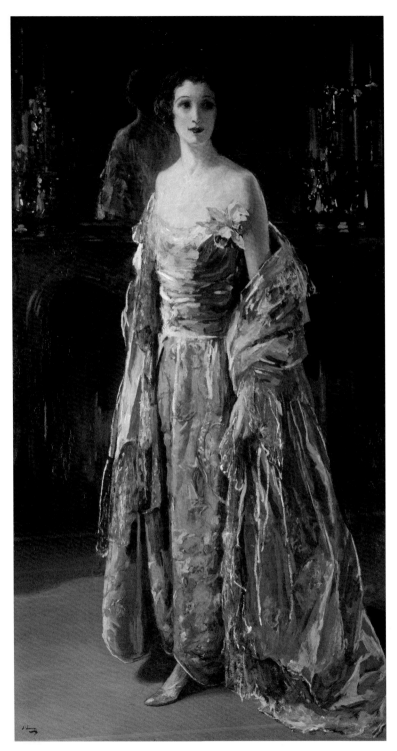

SIR JOHN LAVERY
1856–1941

The Green Coat

1926
Oil on canvas
198.4 x 107.8 cm
Signed bottom left,
J. Lavery;
dated on reverse
Donated by the artist, 1929
U68

The bravura treatment of paint in *The Green Coat* is based on a close study of the skilful techniques used by Velázquez to create the impression of embroidery and gauzy lace. As with the Spanish master the costume appears finely painted when viewed from a distance, but when examined closely becomes a complex pattern of abstract brushstrokes. Lavery's full-length portraits usually have an air of theatrical formality, however the warm firelight and fragility of Hazel's unadorned shoulders make this a tender and intimate study of the painter's wife.

Lavery was a skilled society portraitist and although he could adapt his fluid, impressionistic technique to almost any subject or situation he had an intuitive feel for creating an elegant and arresting likeness. In 1909 he married as his second wife, Hazel Martyn, a beautiful and artistic young American. Possessed of dramatic good looks and theatrical poise, Hazel became the subject of many of Lavery's most successful female portraits. In 1917 he painted her as *The Madonna of the Lakes* for St Patrick's, the church in Belfast where he was christened and in 1927 as *Kathleen ni Houlihan*, the personification of Ireland, for the currency of the new Irish State.

AS

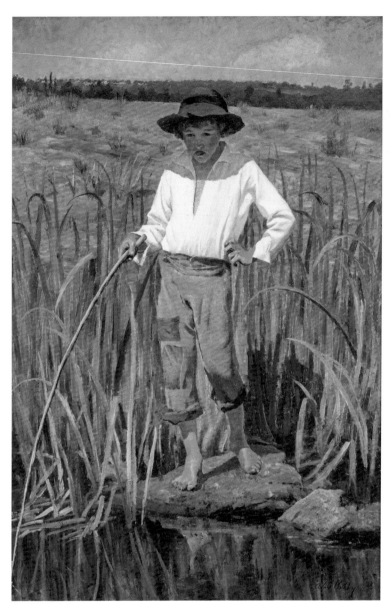

ALOYSIUS O'KELLY
1853–after 1941

Huckleberry Finn

c.1885
Oil on canvas
91.3 x 59.3 cm (sight)
Signed bottom right,
Al. O'Kelly
Donated by Mervyn Solomon,
Belfast, 1996
U5035

There is a distinct *plein-air* – open air – feeling to this work, in the effects of the strong sunshine and the reflections in the still water. Framed by the tall reeds, Huckleberry seems almost part of the landscape, his patched trousers blending in with the vegetation around him. O'Kelly is said to have been acquainted with the American writer Mark Twain, author of *The Adventures of Huckleberry Finn* and to have been commissioned by him to execute the picture around 1885, the year in which the book was published. However, as this pre-dates by ten years O'Kelly's emigration to the United States – and he is not known to have been there in the mid-1880s – the origins of the picture remain something of an enigma.

A highly versatile artist, O'Kelly worked in a variety of styles, from *plein-air* naturalism to Impressionism and Realism. During the 1870s, 1880s and 1900s, he painted in Brittany, at Pont-Aven and Concarneau. He also worked in North Africa during the 1880s and 1890s and was an illustrator for the *Illustrated London News* and the *Pictorial World.* An elusive and restless individual, he was a brother of James J. O'Kelly, the Irish Republican Brotherhood revolutionary, gun-runner and journalist. The 1980s saw a revival of interest in his work, which had been neglected for many years. The date of his death remains a mystery, as do numerous aspects of his life.

EB

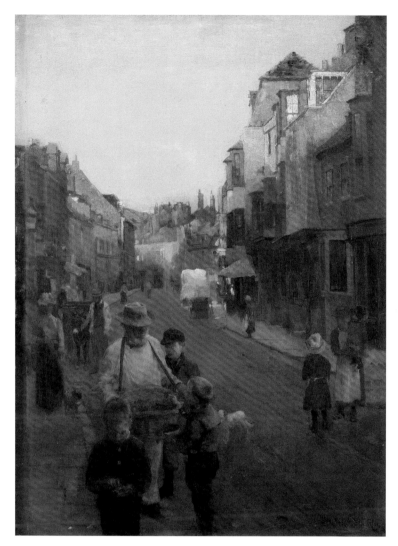

WALTER OSBORNE

1859–1903

Cherry Ripe

1889
Oil on canvas
68.5 x 50.5 cm
Signed and dated, bottom right,
Walter Osborne 89
(date is indistinct)
Purchased 1951
U116

High Street in the Sussex town of Rye is the
setting for this evocative street scene, which
is permeated with a feeling of the open air,
in its sense of light and atmosphere, its loose
Impressionistic brushwork and 'snapshot'
composition. However, whilst Osborne was
influenced by *plein-airism*, he never completely
espoused its methods, preferring instead to
work in the studio from oil and pencil sketches
made on the spot. A number of studies for this
picture exist and also a photograph, as revealed
by Osborne's photograph album in the National
Gallery of Ireland, which contains an image of
the street, taken from close to the same spot.

One of the most important Irish landscape,
genre and portrait painters of the second half
of the nineteenth century, Osborne trained
in Dublin and Antwerp and on completion
of his studies, worked in Brittany, where he
came under the influence of *plein-air* painting.
On leaving France in 1884, he spent lengthy
periods in England, working on the Suffolk coast
and in Oxfordshire, Berkshire and Hampshire.
He returned to Dublin around 1892. Probably
the best known of the Irish Impressionists,
he excelled at the catching of light effects:
the sunshine and shade in a Dublin park or
the sheen of a lustre jug, captured in a fluent
and lush handling of paint.

EB

**JOSEPH MALACHY
KAVANAGH**

1856–1918

*Gipsy Encampment
on the Curragh*

Oil on canvas
71.5 x 91.6 cm
Signed bottom right,
J. M. Kavanagh
Purchased 1976
U2381

The huge expanse of sky in this painting serves to emphasise the wide open spaces of the Curragh of Kildare, a flat plain of almost 5,000 acres, famous for its race course and military camp. The gipsy encampment on the horizon – a small huddle of caravans far away – also reinforces the feeling of distance within the picture. Kavanagh tended to use rather dark colouring and was little interested in *plein-airism* and Impressionism, despite having spent time in Brittany. The somewhat darkish tones and controlled brushwork seen here are characteristic of his style.

Kavanagh studied in Antwerp in the early 1880s, together with his friends and fellow countrymen Walter Osborne and Nathaniel Hill and in 1883, went to Brittany with Osborne and Hill. He returned to Ireland in 1887 and became a regular exhibitor at the Royal Hibernian Academy, of which he was appointed Keeper in 1910. He was lucky to escape with his life when the Academy building, in which he was living and working, was destroyed during the Rebellion of 1916. The main influence on his art was Dutch, rather than French painting and there is a distinctly northern feel to his work.

EB

NATHANIEL HONE

1831–1917

Landscape with Cattle

Oil on canvas
33.2 x 45.7 cm
Signed bottom right,
NH (indistinct)
Bequeathed by Dr R. I. Best, 1959
U565

Though the setting of this small landscape is unspecified, the picture was probably painted at Malahide, Co. Dublin, where Hone lived for many years. The open spaces of the area appealed to him, the large skies and far vistas enabling him to capture atmosphere and distance. Aspects of the painting are strongly typical of his style, notably the predominance of muted greens and browns rather than bright colour and the use of loose and fluid brushwork, a characteristic of his later years. Hone was a master at depicting the changing moods of the Irish climate and this little scene bears all the signs of an impending break in the weather: the heavy clouds threatening rain and the dull, overcast light.

Hone's naturalistic approach and free brushwork stemmed from his early involvement with the Barbizon school, the influence of which remained with him all his life. One of the first of the numerous Irish artists who went to France during the second half of the nineteenth century, he spent seventeen years in the country from 1853, working at Barbizon and Bourron-Marlotte in the Forest of Fontainebleau and also in Brittany, Normandy and the Mediterranean coast. On his return to Ireland in 1872, he settled at Malahide, where he painted many beach scenes and landscapes. He is a major figure in Irish landscape painting.

EB

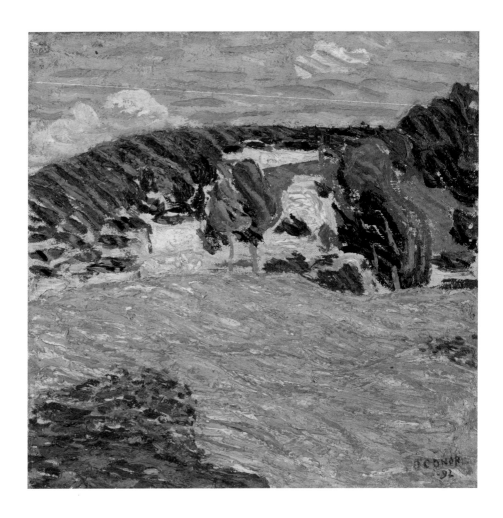

RODERIC O'CONOR

1860–1940

Field of Corn, Pont-Aven

1892
Oil on canvas
38 x 38 cm
Signed and dated, bottom right,
O'Conor 92
Purchased 1963
U389

In 1887 O'Conor arrived in Paris to continue his academic training under Carolus-Duran and quickly became absorbed by the artistic innovations of Impressionism and the work of Van Gogh and Cézanne. By 1892 O'Conor had settled at Pont-Aven, an artists' colony in Brittany, where he painted landscapes and peasant studies using thickly applied stripes of unmixed colour to model form and shadow. *Field of Corn, Pont-Aven* is one of the earliest of his Breton landscapes and the expressionistic technique and reverence for pure colour show the influence of Van Gogh. The small, square format of the canvas serves to intensify the energy of the painting and the thickly painted yellow of the ripening corn suggests a river in spate surging through the landscape.

Roderic O'Conor was born in Co. Roscommon, into a family of lawyers descended from the ancient High Kings of Connaught. His artistic training began in Dublin at the Metropolitan School of Art and continued in Antwerp under Verlat, who admired the forceful realism of Courbet. Unlike other Irish artists of his generation O'Conor remained in France for the rest of his career and became closely involved with the artistic movements that developed in the aftermath of Impressionism.

AS

RODERIC O'CONOR

1860–1940

View of Pont-Aven

1899
Oil on canvas
54.5 x 65 cm
Signed and dated, bottom right,
R. O'Conor 99
Purchased 1983
U2675

View of Pont-Aven marks a departure from the forceful, expressionistic style of O'Conor's early Breton landscapes. The characteristic stripes of pure colour are more muted and the influence of Van Gogh has been reduced to the heavy slashes of dark green, black and orange paint used to depict the wooded hills and sunlit field. In the sky and buildings O'Conor has introduced a more delicate tonal range, using light washes of pink and violet paint applied so thinly that they merely stain the canvas. This heightened sensitivity to colour and the sombre visionary quality he gives to the landscape are the result, in part, of his recent association with Paul Gauguin.

In 1894 Gauguin had returned to Pont-Aven from the South Seas and a close friendship developed between the two artists. Gauguin dedicated two prints to O'Conor and in the following year suggested that they travel to Tahiti together to paint. O'Conor declined the invitation but in the period that followed used a richer tonality, influenced by Gauguin's fascination with flat areas of saturated colour. O'Conor spent long periods working in Brittany during the 1890s and became closely associated with many of the artists of the Pont-Aven School.

AS

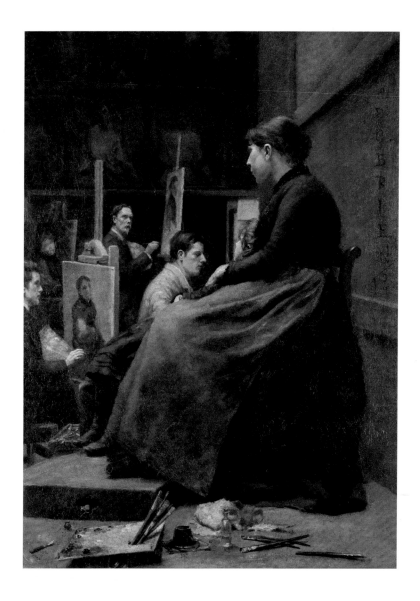

DERMOD O'BRIEN

1865–1945

The Fine Art Academy, Antwerp

1890
Oil on canvas
79.5 x 59.7 cm
Signed and dated, mid-right,
D O Brien 90
Purchased 1982
U2643

Dermod O'Brien was an accomplished painter in the academic tradition and a skilled and fluent draughtsman. A grandson of the Young Ireland leader William Smith O'Brien, he resisted family pressure to enter a profession and instead chose to study painting. O'Brien was a pupil at the Académie Royale des Beaux-Arts, Antwerp, from 1887 to 1891, at a time when it provided one of the most traditional academic training courses in Europe. This interior scene of one of the painting rooms provides a visual record of the method taught at the Antwerp Academy.

The pose adopted by the two young women was chosen to test the students' ability to paint the relationship between figures. A young girl rests against her mother and the students carefully recreate the figure group as an exercise in developing their skill of observation and fluency in painting. The students' expressions of concentration, as they look to the model and back to their canvases, illustrate the arduous nature of this method of study. O'Brien had a natural affinity with this practice and throughout his career remained strongly influenced by the academic training he had received at Antwerp.

AS

DERMOD O'BRIEN

1865–1945

The Estuary of the Shannon

1935
Oil on canvas
50.7 x 60.9 cm
Signed and dated, bottom left,
D. O Brien 1935
Bequeathed by Dr R.I. Best, 1959
U629

O'Brien spent long periods in his native Co. Limerick, mostly on the family estate at Cahirmoyle, near Ardagh. The paintings he made there of his family, familiar landscapes and rural activities are among his most assured and lyrical. This view of the Shannon was painted near his birthplace, Mount Trenchard, a house near Foynes belonging to his mother's family, the Spring-Rices. Painted late in his career and long after the sale of Cahirmoyle in 1920, O'Brien depicts a rich landscape of fertile cornfields with newly-harvested stooks stretching down to the wide grey Shannon. O'Brien made many studies of sky and clouds and was particularly skilled in the depiction of the expansive skies of the west of Ireland.

O'Brien had a long apprenticeship as a painter, studying in Antwerp and Paris and at the Slade School in London. In 1901 he returned to Dublin, intending to establish himself as a portrait painter. He served as President of the Royal Hibernian Academy from 1910 until his death in 1945 and came to epitomise the academic tradition of painting in Ireland. He produced many portraits but is best known as a landscape painter of considerable skill and sensitivity.

AS

SIR WILLIAM ORPEN

1878–1931

Resting

1905
Oil on canvas
76.2 x 55.6 cm
Signed and dated, bottom right,
William Orpen 1905
Donated by Miss Penelope
Andrews and Miss Helen M. Brett,
Belfast (on behalf of a group of
subscribers), 1906
U114

Resting owes much to Orpen's admiration of the work of Manet and Chardin. The bored resignation of the young washerwoman, whose voluptuous beauty is unnoticed in the squalid setting of the steamy laundry, is reminiscent of the displaced young women who appear in Manet's bars and music halls. Orpen's reverence for Chardin grew from that artist's ability to use simple genre subjects, such as a resting servant, to display his faultless handling of paint. The model used for *Resting* was one of Orpen's favourites, a young washerwoman called Lottie Stafford, who lived in a decrepit street called Paradise Walk.

A precocious painter and a brilliant draughtsman, Orpen trained at the Metropolitan School in Dublin and, from 1897, at the Slade School in London. He soon emerged as a leading figure in the bohemian artistic circles of Augustus John and the New English Art Club, and was noted for the assured fluency of his technique. Orpen was the most successful portraitist of his generation and a powerful war artist, producing haunting and memorable images of the conflict. After 1902 he returned to Dublin each year to teach at the Metropolitan School, where he influenced a generation of young Irish painters.

AS

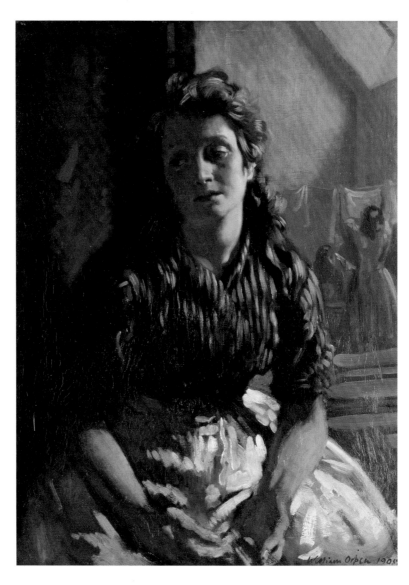

SIR WILLIAM ORPEN

1878–1931

Self-Portrait

c.1905–10
Oil on canvas
50.8 x 40.7 cm
Signed bottom left,
Orpen
Purchased 1933
U481

As a portraitist, Orpen had a remarkable facility for capturing a piercing likeness and imbuing his sitters with an air of casual nonchalance. Throughout his career he painted himself many times and, like Rembrandt, used the self-portrait as a powerful tool to explore his own personality. This work is probably a study for one of a series of theatrical self-portraits he made during the early years of the twentieth century, in which he appears in the mock-heroic guise of a huntsman or a jockey. In most of his self-portraits, Orpen confronts the viewer directly; however, in this small oil sketch, his eyes are lost in shadow, creating a sense of introspection and melancholy.

Orpen's technical skills were formidable and allowed him to absorb influences from earlier painters in a way that was rarely forced or derivative. He was drawn to the overt realism of Manet and the mastery of technique he found in Velázquez. The great Spanish painter lies at the heart of Edwardian portraiture and for artists of Orpen's generation, this influence was inescapable. Orpen, more than any of his contemporaries, rose to the challenge of translating the work of the great masters into a modern idiom.

AS

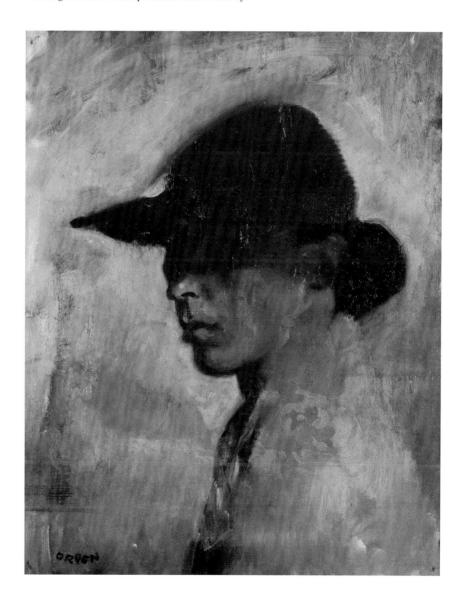

MARY SWANZY

1882–1978

Flowerpiece

c.1913
Oil on canvas
98.8 x 81.5 cm
Signed bottom right,
Swanzy
Purchased 1975
U2324

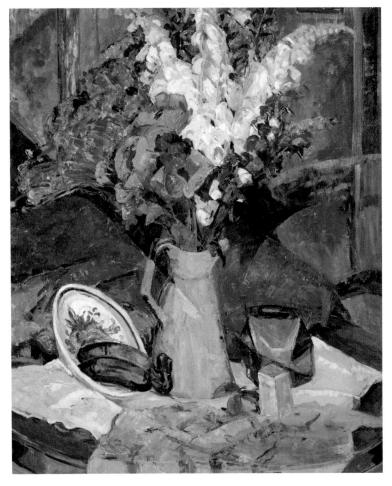

When asked about this picture in 1975, Swanzy replied that as far as she could remember, it had been painted in Florence in 1913. A Fauvist influence can be detected, in the distorted forms of the objects on the table, the flat patterning of the various shapes, with little sense of space or depth and the use of vivacious colour. Swanzy was in Paris in 1905 when the Fauves – a group of avant-garde artists such as Matisse, Derain and Rouault – showed their works at the Salon d'Automne and caused a sensation. Despite absorbing other styles, especially Cubism, Fauvism was to remain an influence on Swanzy's art thereafter.

Swanzy studied in Paris for two separate periods between 1905 and 1907 and there saw works by leaders of the Modern movement like Picasso, Cézanne, the above-mentioned Fauves and others; indeed, she was one of the first Irish artists to be familiar with Cubism. Nonetheless, on returning to Dublin, she continued to paint in a conventional manner for years and did not exhibit avant-garde works there until 1919. These were mainly Fauvist in treatment. She began working in a Cubist idiom around 1920, pictures executed in a manner akin to the late Cubism of Delaunay and Gleizes. In 1926 she left Dublin for London, which became her base for the rest of her life. There is a strong French feeling to her art.

EB

CHARLES LAMB
1893–1964

A Lough Neagh Fisherman

1920
Oil on canvas
76 x 50.8 cm
Signed and dated, bottom right,
C. Lamb 1920
Purchased 1922
U345

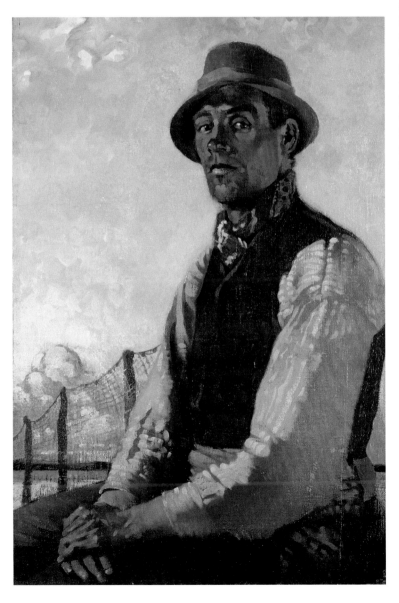

Silhouetted against a pale blue sky, this handsome young fisherman cuts a romantic figure as he gazes directly at the spectator, hat set at a jaunty angle, his vivid red waistcoat and scarf emphasising the ruddiness of his cheeks and rawness of his weather-beaten hands. With his measured look and air of self-containment, he seems to epitomise the dignity of the working man. The portrait is a striking testament to Lamb's skill in the fluent handling of paint and his feeling for character.

Best known as a landscape painter, Lamb trained in Belfast and Dublin and was a member of the Society of Dublin Painters and Royal Hibernian Academy. In 1922 he left Dublin for Connemara and settled at Carraroe, a village within the Gaeltacht. So enchanted was he with the west of Ireland and its way of life that the area dominated his work thereafter. In 1935 he built a house at Carraroe and started a summer school of painting. He was one of the first artists to use the west as a source of subject matter, the others being Paul and Grace Henry and Seán Keating.

EB

PAUL HENRY

1876–1958

Dawn, Killary Harbour

1921
Oil on canvas
69.1 x 83.3 cm
Signed bottom left,
Paul Henry
Purchased 1923
U301

Henry painted *Dawn, Killary Harbour* in the early summer of 1921 and it marks the end of his Achill period and his reverence for the restrained tonality of Whistler. The soft limpid tones of grey and mauve appear to dissolve together making the long inlet of Killary Harbour seem an unearthly place, cut off from the world and the harsh Atlantic beyond. Henry had first visited Achill in 1910, encouraged by a friend, the writer Robert Lynd and by reading Synge's play *Riders to the Sea* (1904). Henry and his wife Grace, who was also a painter, were impressed by the magnificent natural scenery and the simple austerity of life on Achill and made the island their base for the next nine years.

The son of a Baptist minister, Henry studied at the Belfast School of Art before moving to Paris in 1898. There he attended the Académie Carmen, recently established by Whistler and was impressed by the work of Millet and Cézanne. On Achill, Henry returned to his study of Millet and painted the islanders in their distinctive brightly coloured costumes set against high seas and powerful skies. Later in his career Henry continued to paint in the west of Ireland and his accomplished, though formulaic, landscapes have come to symbolise the Ireland of the popular imagination.

AS

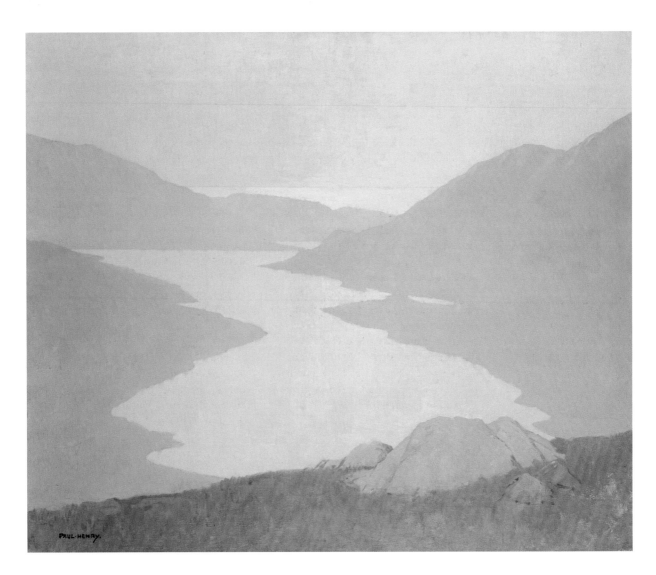

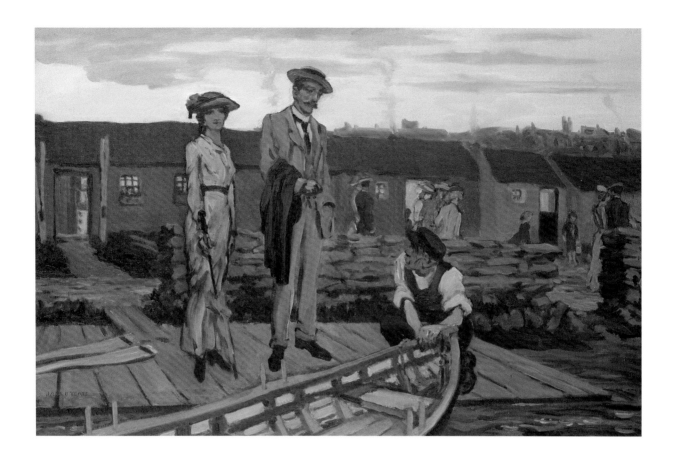

JACK BUTLER YEATS

1871–1957

The Riverside (Long Ago)

1922
Oil on canvas
61.4 x 91.7 cm
Signed bottom left,
Jack B Yeats
Purchased 1967
U428

When *The Riverside (Long Ago)* was exhibited in Dublin in 1922 the Edwardian costumes and muted colours evoked a sense of nostalgia for the recent past. The Riverside was an area of Sligo Town, on the banks of the Garavogue river, where boats could be hired to visit Lough Gill. The couple who are about to embark seem caught in private reverie, their urban clothes setting them apart from the old man who draws in the boat. Many of Yeats's paintings are based on memories of his Sligo childhood, re-interpreted to illustrate universal themes of human experience.

Born in London, Jack Yeats was the youngest child of the painter John Yeats and brother of the poet W.B. Yeats. As a boy he spent long periods with his grandparents in Sligo and developed a deep respect for the folk traditions and sea-faring heritage of the west of Ireland. He trained at the Westminster School of Art in London and began his career as an illustrator. In 1910 he returned to Ireland and began to paint using strong saturated colour and bold outlines. His work often depicts themes of exile and isolation and during his early period frequently illustrated the growing political tensions in Ireland before Independence.

AS

JACK BUTLER YEATS

1871–1957

Return of the Wanderer

c.1928
Oil on board
22.8 x 35.6 cm
Signed bottom right,
J.B. Yeats
Morrison Bequest, 2009
U5160

Return of the Wanderer depicts a self-confident Irishman returning to the place of his youth. Across a shallow stream a row of low cottages allude to the poverty that now contrasts with the man's conspicuous watch chain and proud bearing. The homecoming is one of optimism, as the man leaves behind the darkness of the mountains and turns his face towards the west and the great light in the sky. Around the time Yeats made this painting, themes of exile and homecoming came to play an increasingly important role in his work. The similarity of the mountain to Ben Bulben, in Sligo, where Yeats spent much of his boyhood, suggests the work had a deeper personal significance.

The mid-1920s represents a transitional period in Yeats's development as a painter, when he largely abandoned the sombre colours and dark outlines of his early work and began to paint in a much looser manner. His pigments became richer and fragment into mosaic-like surfaces, as he found greater freedom and exhilaration in his handling of paint. Yeats described this dramatic change in his painting as 'a kind of new birth',[10] which made possible the visionary work that followed in the 1930s and 1940s.

AS

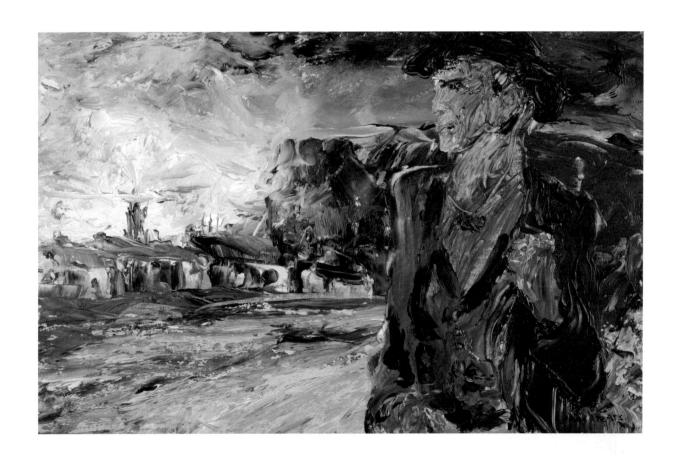

JACK BUTLER YEATS

1871–1957

On Through the Silent Lands

1951
Oil on canvas
50.6 x 68.3 cm
Signed bottom left,
Jack B Yeats
Purchased 1962
U430

Painted in the artist's eightieth year, *On Through the Silent Lands* depicts a stooped man walking towards the edge of a thickly painted landscape of rich earth colours. Beneath him, a bridge crosses a wide river and beyond stretches a country of high shimmering mountains and lightly-painted luminous lakes. The painting suggests a preparation for death, together with a sense of the quiet joy and release for the figure soon to cross to the far country. Yeats chose the titles of his paintings carefully, adapting historical and literary texts to suit his own interpretations and associations. The title of this painting is thought to derive from the lines in 'Remember', a poem by Christina Rossetti, 'Remember me when I am gone away, Gone far away into the silent land'.

The work of Jack Yeats dominated Irish artistic life during the first half of the twentieth century. No other artist possessed his depth of vision or powerfully intuitive handling of paint. His style was largely self-taught although he did have contact with Oskar Kokoschka and European Expressionism. Throughout his career Yeats had the ability to create a poetic mood in his paintings and to evoke feelings and emotions in a manner comparable to poetry and drama.

AS

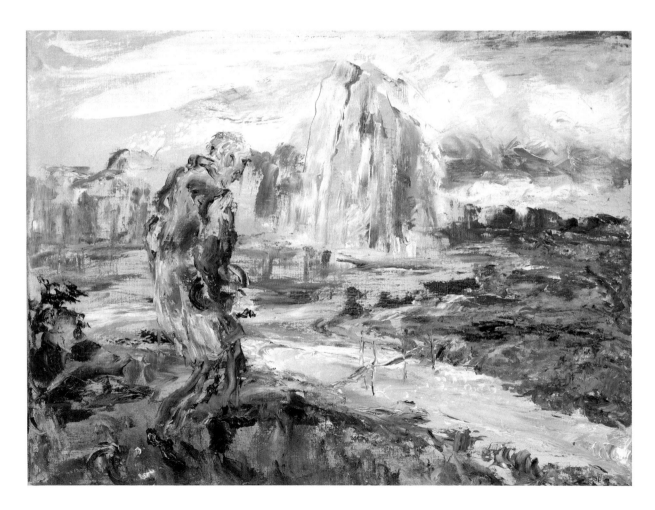

WILLIAM JOHN LEECH

1881–1968

Aloes

c.1920
Oil on canvas
181 x 148.3 cm
Signed bottom left,
Leech
Purchased with the aid of
a grant from the National
Heritage Memorial Fund, 1984
U2709

Aloes is one of the earliest of a series of paintings Leech made during the 1920s of the exotic, sculptural plants he found near Les Martigues, on the French Mediterranean coast. The series marks an important development in his career as it introduced the study of vegetation as a distinct and absorbing subject in his painting. Often taken from a high viewpoint, Leech's Aloe studies concentrate on the powerful silhouettes of the plants and the rich colour harmonies created by their shadows. The dry jagged points of the immense leaves suggest the influence of Seurat, who placed heavy forms against much lighter backgrounds made up of dotted colour.

Born in Dublin, Leech trained at the Royal Hibernian Academy School where he developed a strong regard for Walter Osborne. In 1901 he moved to Paris to study at the Académie Julian and in 1903 settled at Concarneau, in Brittany, where he remained for the next five years. During his early career Leech produced many landscape studies based on the subtle tonal harmonies of Whistler and Monet and his response to the strong light and intense colour of Brittany was measured and gradual. Later he developed a strong colourist style that was closely linked to developments in Post-Impressionism.

AS

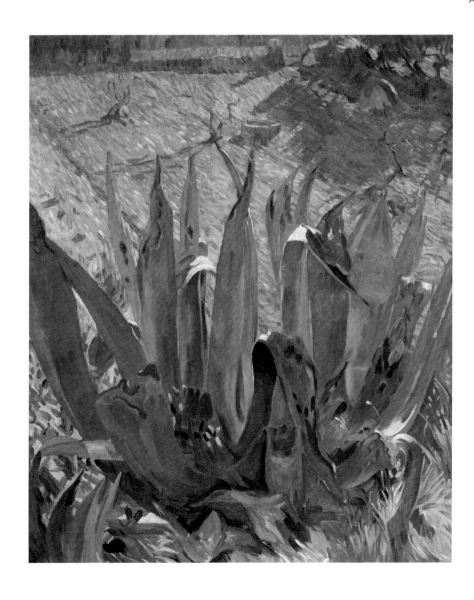

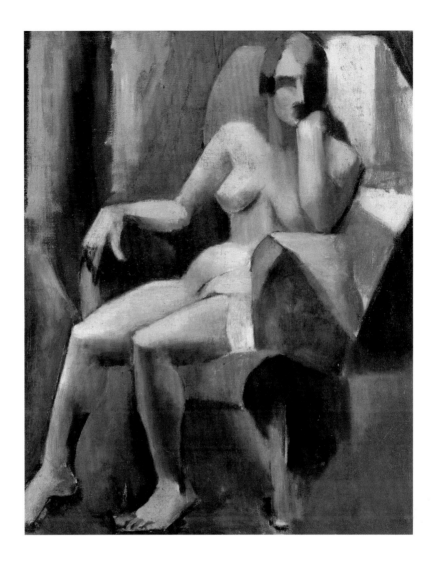

MAINIE JELLETT

1897–1944

Seated Female Nude

1921–22
Oil on canvas
56.3 x 46.2 cm
Purchased 1975
U2293

Seated Female Nude was painted in Paris soon after Jellett began working in the Cubist style under André Lhote. The work shows a deliberate move away from figurative painting and marks an important stage in her progress towards abstraction. The reduction of the composition to a series of flattened surfaces shows Jellett's understanding of the essential principles of Cubism. The influence of Cézanne, however, can still be discerned in the three-dimensional quality of the figure. Jellett became increasingly interested in the process of abstraction and late in 1921 approached Albert Gleizes to instruct her in the more advanced elements of Cubist theory.

Born in Dublin, Jellett trained at the Metropolitan School and in 1917 moved to London, where she studied under Sickert at the Westminster School of Art. In 1921–22 she worked under Lhote and Gleizes in Paris and made rapid progress towards pure abstraction in her painting. The two Cubist paintings she exhibited in Dublin in 1923 met with fierce criticism, particularly from the critic George Russell who deplored their modernity. During the rest of her career Jellett campaigned for the recognition of modern art in Ireland and in the year before her death played an important role in founding the Irish Exhibition of Living Art.

AS

FRANK MCKELVEY
1895–1974

Evening, Ballycastle

c.1924
Oil on canvas
76.5 x 102 cm
Signed bottom left,
Frank McKelvey
Purchased 1924
U328

Evening, Ballycastle is one of McKelvey's finest early works, with a strong sense of air, light and atmosphere. The inclusion of a few figures to add a human dimension to the scene and the use of thick paint to accentuate particular details, are characteristic of his style. The mood of the painting is one of tranquillity at the end of the day. Until about 1924, McKelvey generally painted in and around Belfast and in counties Antrim and Armagh but in that year, began also to work in Co. Donegal, possibly influenced by fellow artists James Humbert Craig and Paul Henry, who were already working there and in the west. McKelvey himself did not begin painting in the west for another ten years.

Trained at Belfast School of Art, McKelvey was well established in the city as a landscape and portrait painter by the mid-1920s, when this picture was executed. Though a portraitist of distinction, it is for his landscapes that he is best known and valued in the north of Ireland. Interestingly, the distinct Irish school of landscape painting which he, Craig, Henry and a few others helped create, was almost entirely a northern-led affair, though a few southerners, such as Seán Keating and Maurice MacGonigal, also played a part.

EB

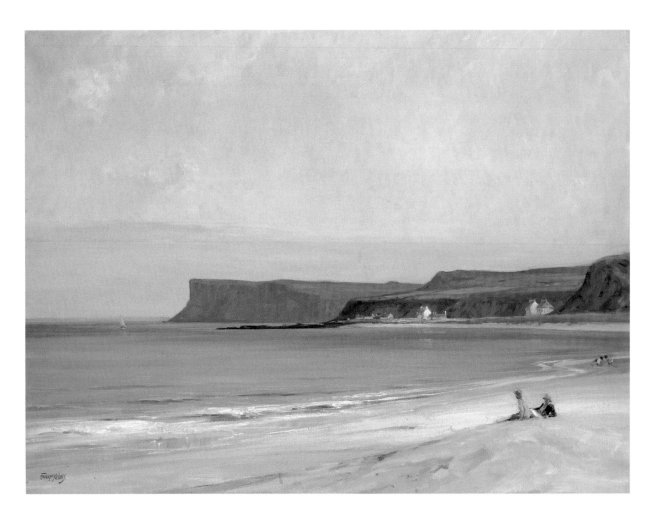

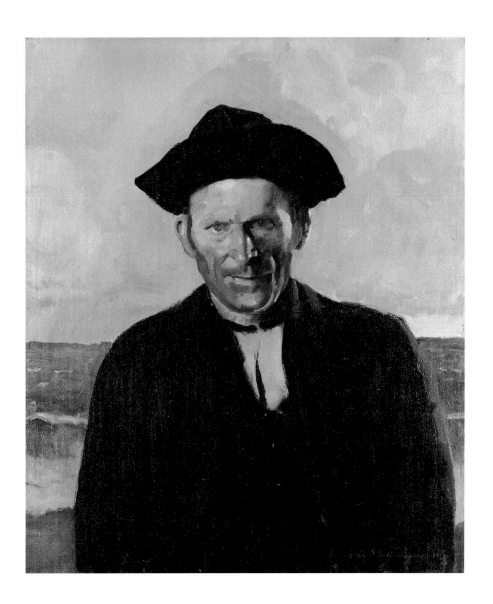

SEÁN O'SULLIVAN

1906–64

Neach

1928
Oil on canvas on board
60.5 x 50.6 cm
Signed and dated, bottom right,
Seán O'Sullivan ARHA 1928
Donated by the Thomas
Haverty Trust, 1936
U388

O'Sullivan's use of the title *Neach,* meaning person in Irish, suggests that he intended to paint a national type rather than portray an individual. Painted in the year he returned from Paris, *Neach* represents the application of the skills he had learnt abroad to a subject that is overtly Irish. The bright, lucid tones of the sea and the piercing blue eyes of the sitter give the work a freshness and immediacy that is rarely found in the repetitive urban portraits of O'Sullivan's later years.

O'Sullivan was born in Dublin and trained at the Metropolitan School of Art. He continued his training in London at the Central School of Art and in 1927 moved to Paris, where he studied at Colarossi's. He returned to Dublin in 1928 and quickly became a popular portraitist. A skilled draughtsman, O'Sullivan had a strong feeling for personality and was widely respected for his ability to produce accomplished pencil and charcoal portraits. Sitting to O'Sullivan at his studio in Molesworth Street or, later, on St Stephen's Green became an established Dublin tradition, undertaken by many of the political and literary personalities of the period.

AS

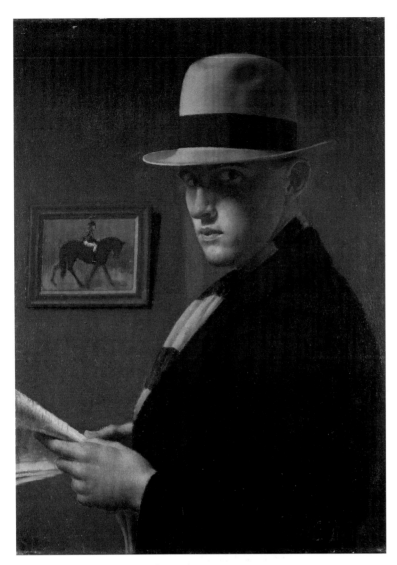

JOHN LUKE
1906–75

The Tipster

1928
Oil on canvas
56 x 40cm
Signed bottom right,
J. Luke
Purchased 1979
U2525

Although not entitled as such, this painting of a somewhat raffish young man is almost certainly a self-portrait. Looking out furtively from under the brim of his hat, his face partly in shadow, he seems to be offering the spectator a tip, presumably at a price. The framed painting of a horse and jockey in the background, on the wall of what is perhaps a bookmaker's shop, is an obvious reference to his association with the turf. In its emphasis on line and lack of unnecessary detail, the work seems to presage the more fanciful and stylised approach Luke pursued later in his career.

A painter of landscapes, figure subjects and murals, Luke studied at Belfast School of Art and the Slade School of Art in London. He returned to Belfast in 1931 and remained in the city for the rest of his life, with the exception of a period in Co. Armagh between 1941 and 1950. One of his best-known works is his mural of 1951 representing the life and history of Belfast, on the tympanum of the inner dome of Belfast City Hall. His paintings from the early 1930s are distinguished by extreme stylisation of shapes and the use of bright colour; images at once realistic but with a surreal, dreamlike quality.

EB

JOHN LUKE

1906–75

The Three Dancers

1945
Oil, tempera on canvas
on board
30.7 x 43 cm
Signed and dated, bottom right,
Luke 1945
Purchased 1945
U1919

The Three Dancers is a prime example of Luke's highly stylised and precise technique. The flowing lines of the dancers' arms, the bending boughs of the bush and the wavy undulations of the landscape, create the rhythm of the dance in a powerfully immediate way. The subtle finish and intense colour derives from the use of tempera, a medium Luke began experimenting with in 1933 and which fascinated him. The colour itself has a happy resonance, the vivid oranges and reds being as uplifting as the movement of the dance. The image of dancing clearly appealed to Luke; his *Dancer* of 1947 (private collection), showing a female dancer twirling to a fiddler's music, is even more rhythmical and vigorous.[11]

By the 1940s, Luke had become virtually obsessed with the craftsmanship involved in creating works like *The Three Dancers*. Describing the picture in a letter of 1945 to John Hewitt, Keeper of Art in the then Belfast Museum and Art Gallery, he declared, 'It is an interesting piece of craftsmanship … [in it] I have practically reached the limit of my knowledge'.[12] Indeed, such was his preoccupation with the making of the picture that he produced lengthy notes on its technical construction.

EB

HILDA ROBERTS

1901–82

Portrait of George Russell ('AE')
(1867–1935)

1929
Oil on canvas
76.2 x 63.8 cm
Signed and dated, bottom left,
Hilda Roberts 1928
Purchased 1936
U392

Described by Crookshank and Glin as one of the great portraits of the first half of the twentieth century, this painting of 'AE' is indeed a masterpiece of the portrait painter's art.[13] Beetle-browed and intense, he looks directly at the spectator, tugging his lapels as if emphasising a point in conversation. Such a dynamic portrayal seems entirely apt for this 'myriad minded' man, whose career comprised that of poet, painter, mystic, economist, journalist and prominent participant in the Irish Literary Revival. The work was painted in the library of his home in Rathgar Avenue, Dublin, with the accoutrements of his life in the background, namely, his books and one of his mystical-themed pictures.

The painting was an extremely prestigious commission for the young Dublin portrait painter Hilda Roberts, who apparently executed the work on six Sunday mornings and found her sitter 'a very interesting and sympathetic person to paint'.[14] Besides portraits, Roberts produced landscapes and book illustrations and was a regular exhibitor at the Royal Hibernian Academy until 1979.

EB

WILLIAM CONOR
1881–1968

The Jaunting Car

c.1933
Oil on canvas
70.9 x 90.9 cm
Signed bottom left,
Conor
Donated by the
Thomas Haverty Trust, 1936
U254

One of Conor's best-known scenes of working-class life, *The Jaunting Car* is a poignant image of Belfast during the Thirties. The mood of the picture is one of downtrodden misery, from the shawled mother, baby and girl huddled together for warmth or comfort, to the child at the back of the car, gazing forlornly into space. Whilst the painting is not entirely successful in compositional terms – the figures and the street seem to be on entirely different planes – its strength lies in its emotional appeal. Figure compositions like this were amongst Conor's most popular works.

Trained at Belfast School of Art, Conor's preferred definition of himself was as a 'portraitist, landscapist and genre painter.' However, he is best known for his scenes of Ulster working-class life – women gossiping in the street, children playing, scenes in the workplace; also, for his work as an official war artist on the Home Front during both World Wars. His working-class subjects made him unique amongst artists in the north of Ireland; indeed, few painters within Ireland as a whole pursued such genre themes, with the exception of Jack B. Yeats and Paul Henry.

EB

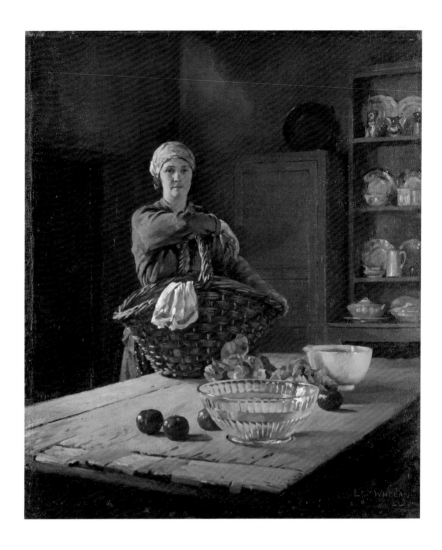

LEO WHELAN

1892–1956

Interior of a Kitchen

c.1934
Oil on canvas
68.3 x 57.5 cm
Signed bottom right,
Leo Whelan
Donated by the
Thomas Haverty Trust, 1941
U508

An academic painter of great skill, Whelan particularly admired seventeenth-century Dutch painting. Like Vermeer, the artist he most revered, Whelan often used his family and domestic surroundings as the subject matter of his work. This preference for tradition gives his interior scenes an air of nostalgia and the sense that they depict an earlier age. The model for this painting, the young woman who leans on a basket and confronts the viewer across a carefully constructed tablescape, is the artist's sister, Frances. The kitchen was in the basement of Whelan's house in Eccles Street, Dublin. Whelan clearly relished the challenge of depicting glass, basketwork and fruit in a style that could demonstrate his great skills of observation and technical control.

Whelan trained at the Metropolitan School in Dublin and his accomplished style derives from the academic training and intensive regime of drawing from the model he received under Orpen. He was the most technically skilled portraitist of his generation and painted many influential figures during his long career. He was adept at capturing a likeness and his traditional style gave his sitters a sense of gravity appropriate to official portraiture.

AS

SEÁN KEATING

1889–1977

Slán Leat, a Athair/
Goodbye, Father

1935
Oil on canvas
175.9 x 175 cm
Signed bottom left,
Keating
Donated by the
Thomas Haverty Trust, 1941
U589

Goodbye, Father depicts a scene of departure on Inisheer, the smallest of the Aran Islands. A priest is returning to the mainland and his parishioners have gathered on the beach to bid him farewell. The contrast between the simple lives of the islanders and the intense physical beauty of the landscape fascinated Keating and in *Goodbye, Father* he uses the heavy Atlantic sky and crashing waves to heighten the quiet solemnity of the leave-taking. Traditionally a priest would be the central figure in such a scene but Keating has only shown his back and there is a sense that it is the priest who defers to the stoical toughness of the islanders and the wild beauty of the landscape.

Keating was born in Limerick and studied at the Metropolitan School in Dublin under Orpen, whom he admired. He visited the Aran Islands in 1913–14 and was impressed by the harsh purity of the life there. In 1927 he illustrated Synge's *Playboy of the Western World* (1907) and identified closely with the combination of poetry and realism he found in that work. Keating was one of the few artists of his generation whose work was overtly political and dealt with the complex social and political upheavals of the early years of the new Irish State.

AS

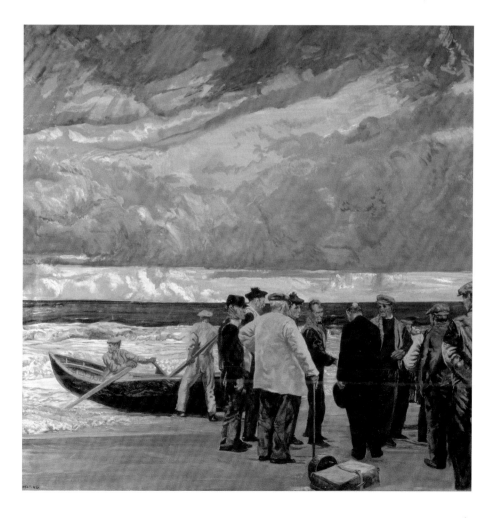

MAURICE MACGONIGAL

1900–79

The Olympia, Dublin

c.1935–36
Oil on canvas
63.6 x 76.5 cm
Signed bottom right,
MacCongail
Donated by the
Thomas Haverty Trust, 1941
U369

During the 1930s Maurice MacGonigal painted a series of urban subjects quite different in spirit from the clear and lucid landscapes of the west of Ireland for which he is best known. *The Olympia, Dublin* is one of the most unusual of the group and suggests the influence of Sickert in the depiction of a faded nineteenth-century theatre interior, with figures and surfaces painted in unnaturally vivid colours. The actors on stage wear faintly ridiculous music hall costumes and are placed at the edge of the composition, heightening the sense of raucous merriment. MacGonigal made numerous pencil studies for this painting during various visits to the theatre, sometimes with the painter Harry Kernoff, who appears on the extreme right in a hat. The other standing figure is Leo Smith, the owner of the Dawson gallery.

MacGonigal was one of the most original and accomplished artists of his generation. He trained in the stained glass studio of his uncle Joshua Clarke and in 1923 won a scholarship to the Metropolitan School, where he was influenced by Keating and Tuohy and later taught. MacGonigal had a lifelong interest in the theatre and designed sets and posters for the Abbey Theatre. He succeeded Keating as President of the Royal Hibernian Academy in 1962.

AS

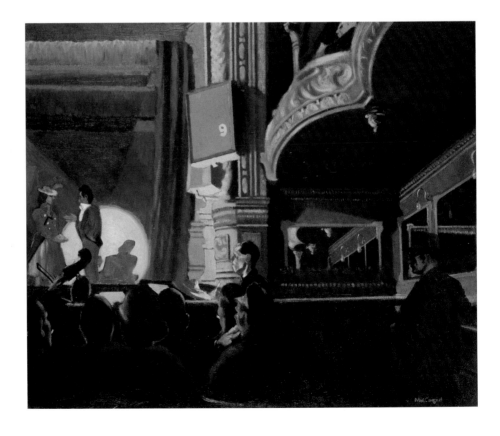

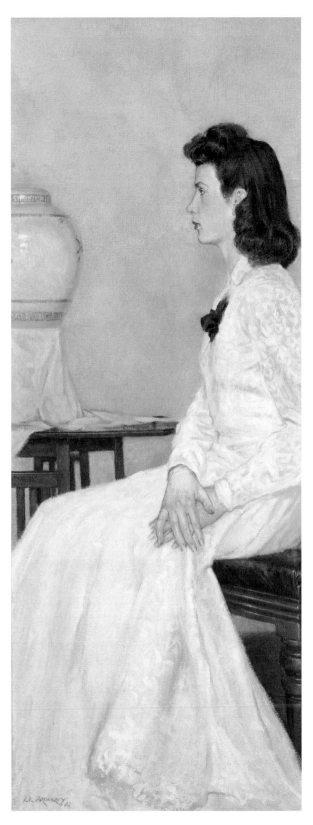

LOUIS LE BROCQUY

b.1916

Girl in White

1941
Oil on canvas on board
122.2 x 47.8 cm
Signed and dated, bottom left,
Le Brocquy 41
Donated by the
Thomas Haverty Trust, 1945
U234

Girl in White is a study of the Dublin-born actress Kathleen Ryan (1922–85), who was cast in her first film *Odd Man Out* by Carol Reed in 1947. The work is one of the first le Brocquy painted after his return to Dublin in 1940 and contains references to many of his interests at that time. The pale, diffused tonality of the work derives from his admiration of Whistler and the narrow composition and elongated forms show the influence of the late eighteenth-century Japanese printmakers Kiyonaga and Utamaro.

Born in Dublin, le Brocquy studied chemistry at Trinity College and worked briefly in his family's oil business. In 1938 he went abroad to study painting and in the following year settled in the south of France. Largely self-taught, le Brocquy studied technique in the galleries of Europe. Of particular importance to him were the paintings from the Prado, Madrid, which were temporarily housed in Geneva before the war. The austere colour harmonies of Spanish painting, particularly those of Velázquez and Goya, have influenced le Brocquy throughout his career and are already apparent in the pale greys and muted browns of *Girl in White*.

AS

LOUIS LE BROCQUY

b.1916

*Variety Rehearsal
at the Olympia*

1942
Oil on board
52.9 x 65.6 cm
Signed and dated, bottom right,
Le Brocquy 42
Donated by the
Thomas Haverty Trust, 1945
U239

In 1942 the Olympia Theatre in Dublin staged *Amphitryon 38*, with sets designed by Louis le Brocquy. The play, written in 1929 by the French dramatist Jean Giraudoux, had recently been translated by the artist's mother, Sybil le Brocquy. Amphitryon was the wife of Alcmene who, in consequence of a liaison with Zeus, gave birth to Hercules. The theme had been treated by many authors, hence the number thirty-eight in the title. During an afternoon rehearsal for a variety production, also being staged at the Olympia, the theatre seats were covered in large dust-sheets. From a vantage point at the back of the stage, le Brocquy was struck by the unintentional theatricality of the draped auditorium.

During the early 1940s le Brocquy's painting became more intuitive and less influenced by the formality of his experiences abroad. He developed an expressionistic style derived from Manet and used subtle tones of white, grey and violet to produce colour harmonies that had similarities with musical structures. At this time he designed a number of stage sets and became aware of the power of theatre design to focus concentration on the actor's presence. This experience contributed to his evolving search for the essence of the human figure in his painting.

AS

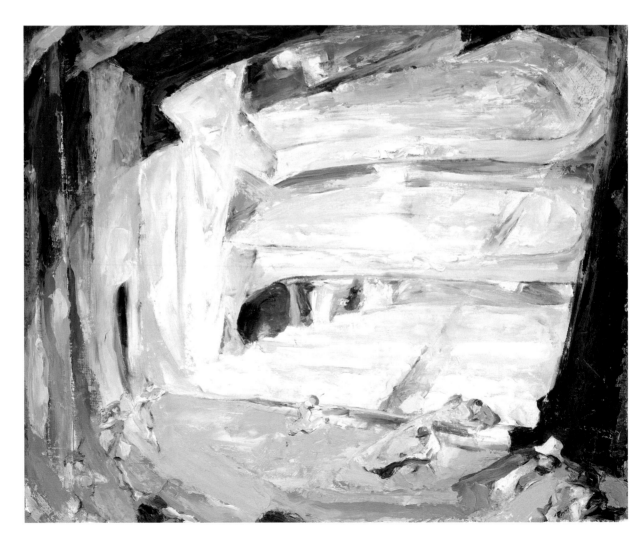

LOUIS LE BROCQUY
b.1916

Recumbent Nude

1958
Oil on canvas
61 x 76.5 cm
Signed and dated, bottom left,
Le Brocquy 58
Purchased 1959
U246

Recumbent Nude is one of a series of torsos le Brocquy painted during the late 1950s and marks an important stage in his development as a painter. During this period he explored ways of representing 'an expression of the human presence' and by painting only a torso he was able to remove any suggestion of individual personality. As his paintings became increasingly abstract there is a sense of the stripping away of inconsequential detail to reveal the true essence of the figure.

In 1955 le Brocquy visited Spain and was impressed by the way piercingly bright sunlight could erase the outline and detail of figures, creating solidity only in the shadows. He used this effect in the torso series where he reduced the human form to small areas of dark paint that appear almost etched into the brightness of the picture surface. In 1946 le Brocquy moved to London and in 1956 represented Ireland at the Venice Biennale. In 1958 he settled in France with Anne Madden, the young Irish painter he had married earlier in the year. *Recumbent Nude* was one of earliest works le Brocquy painted in France.

AS

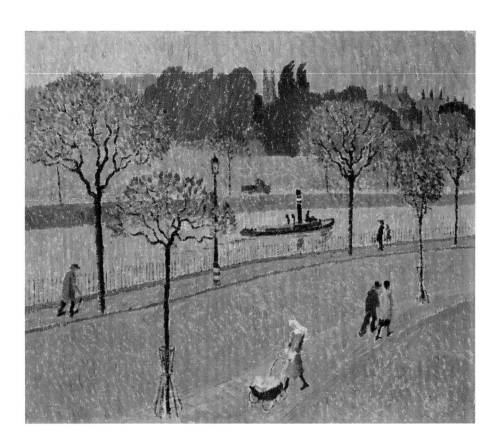

COLIN MIDDLETON

1910–83

Lagan: Annadale, October

1941
Oil on canvas
51 x 61.1 cm
Signed and dated, bottom right,
Colin M 1941 (with monogram)
Purchased 1943
U598

Painted in a loose Impressionistic manner, this Belfast scene shows the Annadale Embankment and river Lagan, with the tower of Queen's University in the middle background, across the river. The low tones of the picture are expressive of the autumn day, the sun slanting on the tower and roofs to the right lifting the otherwise flat atmosphere of the work. With paint laid on thickly in dabs, the matchstick figures and toytown trees are decidedly Lowryesque in appearance. This was the first painting by Middleton to enter a public collection, having been bought by the Belfast Museum and Art Gallery (now the Ulster Museum) at Middleton's first one-man show, held in the gallery in 1943.

Middleton studied at Belfast School of Art on a part-time basis and painted in his leisure hours, whilst employed in his father's firm. In 1935 he was elected an associate member of the Royal Ulster Academy. His show referred to above comprised 115 works and astounded the Belfast public with its variety of styles, fellow artist Tom Carr describing it as 'an amazing anthology of modern art'.[15] Middleton's eclecticism, his incessant experimentation with styles and techniques, is the most distinguishing feature of his art.

EB

COLIN MIDDLETON

1910–83

Christ Androgyne

1943
Oil on canvas
38.1 x 27.8 cm
Signed bottom left,
Colin M (with monogram);
dated on reverse
Donated by Martin Prescott,
Sandyford, Co. Dublin, 1963
U365

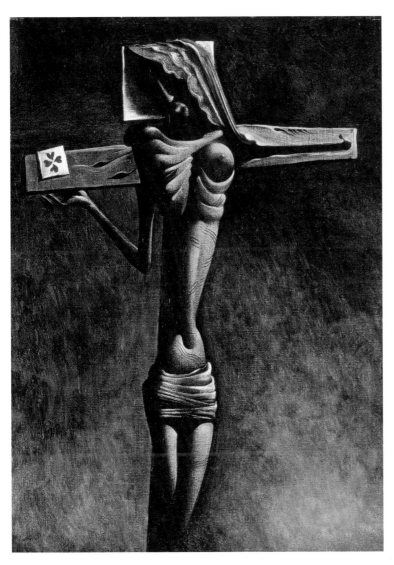

This small carefully-painted canvas, given a precious appearance by the large frame around it, uses a Surrealist idiom to express Middleton's deep unease at the events of the Second World War and the suffering of those caught up in it. By giving Christ female characteristics, he turns the traditional image of the crucified Saviour into a general symbol of all suffering humanity. The painting is a stark and moving metaphor for the times in which it was painted – a period of darkness, desolation and loss.

Despite working full time in his family's damask-designing business until 1947, Middleton managed to establish a successful career as a painter in Belfast. He first began to experiment with Surrealism in 1937; indeed, his *Head* of 1938 (Ulster Museum) is thought to be the earliest Surrealist painting by any Irish artist. Notoriously eclectic, he moved between a variety of styles, maintaining that his need for such experimentation was a natural reaction to external influences and that the twentieth century, with its many psychological complexes, required an artist to be versatile in manner. For his part, he did not try to impose his style on the things he painted but preferred to allow the subject to impose itself on him.

EB

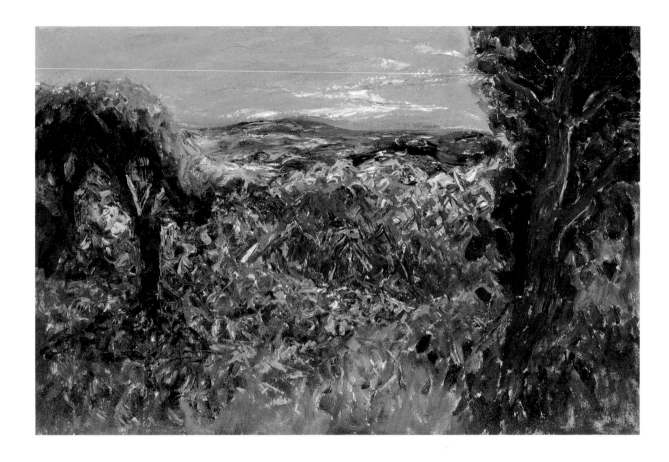

COLIN MIDDLETON

1910–83

September Evening, Ballymote

1951
Oil on canvas
50.8 x 76.4 cm
Signed bottom right,
Colin M (with monogram);
dated on reverse
Purchased 1954
U360

At the time this picture was executed, Middleton was living at Ardglass, Co. Down. Ballymote, where the scene is set, is a townland outside Downpatrick. Middleton has used an Expressionist idiom to convey the landscape; the brushwork is spontaneous and full of vitality and the paint has been applied extremely thickly. The rather frenzied appearance of the middle section of the work is Fauvist in treatment, as is the emphasis on the actual sensation of painting and in the vibrant colours applied in dabs and broken strokes. The sunset sky seems to glow with a life of its own, so powerful is Middleton's rendering of it.

Middleton, whose chief characteristic is his eclecticism, moved between a variety of styles throughout his career, notably Surrealism, Expressionism and an adaptation of Impressionism. In selecting Expressionism with overtones of Fauvism for this work, he aptly conveys the sensation of 'experiencing' this September evening in the country: the blaze of colour as the sun goes down.

EB

GERARD DILLON

1916–71

Yellow Bungalow

1954
Oil on canvas
76.8 x 81.2 cm
Signed bottom right,
Gerard Dillon
Donated by the Thomas Haverty
Trust, 1956
U283

Yellow Bungalow depicts a cottage interior in Roundstone, overlooking Inishlacken, an island off the Galway coast where Gerard Dillon lived during 1950–51. Although he admired the wildness of the landscape in the west, Dillon's main concern was with the customs and daily lives of the islanders. A subject that deeply divided life in the west was the desire of many young people to abandon rural life. In *Yellow Bungalow* that longing is suggested by the sense of unease between the young couple who seem separated by their different aspirations. The young woman sits alone with folded arms, cut off by the tall stove-pipe from the young man who looks out of the painting with thoughtful curiosity.

Largely self-taught, Dillon was influenced by other artists with whom he felt an affinity. Two of his most important influences were Keating's illustrations for Synge's *Playboy of the Western World* and the work of Chagall. In 1954, when he painted *Yellow Bungalow,* Dillon was working in London as a night porter and painting during the day. This work is based on Chagall's *La Chambre Jaune* (1911) and makes similar use of an overwhelming, intense yellow and unnaturally raked perspective to heighten the sense of discord between the figures.

AS

DANIEL O'NEILL

1920–74

Place du Tertre

1949
Oil on canvas
64 x 76.7 cm
Signed bottom left,
D. O'Neill
Bequeathed by
Mrs S.A.Forbes, 1974
U2069

Place du Tertre was painted during O'Neill's first visit to Paris and shows the influence of French painting, particularly the work of Utrillo. The small square near the Sacre-Coeur is inhabited by young people at café tables and the flickering candle-light illuminating their faces creates warm pools of bright colour. In the background the narrow streets of Montmartre are deserted and the lifeless buildings and empty windows anticipate the sense of human isolation that later dominated O'Neill's work. The inky stillness of the night sky and the gaunt facades of the buildings are painted in the cool tones of blue and silvery grey that are characteristic of his work during this period.

O'Neill was born in Belfast and studied briefly at the Belfast College of Art. Like his close associate Gerard Dillon, he worked on night shifts in order to paint during the day. Dillon introduced O'Neill to French painting, particularly the work of Cézanne and the Fauves, and this encouraged his determination to paint. O'Neill's style developed quickly and by 1943, when he first exhibited with Gerard Dillon, he was already displaying a degree of skill and maturity.

AS

DANIEL O'NEILL

1920–74

The Blue Skirt

1949
Oil on canvas
60 x 73 cm
Signed top right,
D. O'Neill
Donated by the
Thomas Haverty Trust, 1951
U384

When *The Blue Skirt* was exhibited at the Irish Exhibition of Living Art in 1949 it was heralded as a modern and innovative interpretation of a traditional subject. The horizontal semi-clothed figure is a pose derived from classical sculpture and was considered one of the greatest challenges in academic painting. The success of O'Neill's powerful, sombre composition is due in part to his highly instinctual feeling for colour. The painting is a complex arrangement of light and shadow in which bright white is used to accentuate the sinuous drapery and luminous sky, and darker tones of blue and turquoise to emphasise the solidity of the figure's blue skirt. The flattened drapery and almond-shaped facial features recall aspects of the early Sienese painting that O'Neill admired and studied from books.

During the 1940s O'Neill pioneered a lyrical and romantic style of painting that was intuitive and largely self-taught. He studied the work of the Fauves, particularly Rouault and Vlaminck and preserved a freshness of vision that was made possible by his lack of formal academic training. In 1946 Victor Waddington, an early supporter, organised his first major exhibition.

AS

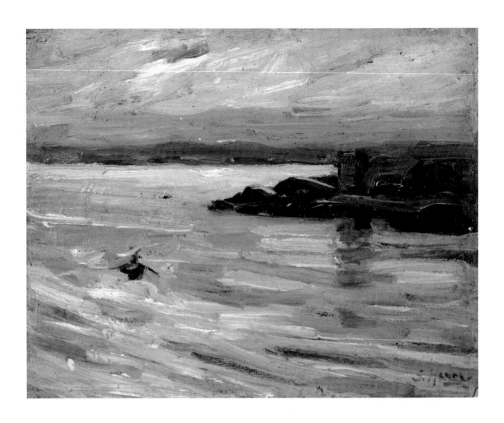

GRACE HENRY

1868–1953

Liscannor

c.1942
Oil on panel
14.2 x 18.1 cm
Signed bottom right,
G. Henry
Bequeathed by J. N. Bryson, 1977
U2435

This small oil sketch of Liscannor Bay, Co.Clare, was painted late in Henry's career, when she was over seventy and shows considerable confidence and assurance in the fluid handling of paint. She may have felt a certain nostalgia returning to the west of Ireland, where she had spent much time during her early marriage and the delicate tonality of the painting recalls the colour harmonies of Whistler which she had admired in her youth.

Born near Aberdeen, Emily Grace Mitchell was the daughter of a Church of Scotland clergyman. In 1899 she went abroad to study painting and the following year settled in Paris. There she met the painter Paul Henry, her future husband, who shared her strong interest in the work of Whistler. In 1910 the couple made their first visit to Achill, off the Galway coast and for the next nine years spent long periods living on the island. Grace was initially enthusiastic in her response to the harsh beauty of the landscape and the customs of the islanders, which she recorded in a series of powerful, Fauvist paintings. Later she found the isolation burdensome and when the couple returned to Dublin in 1919, they became estranged. During the 1920s and 1930s she spent long periods abroad, painting in France and Italy and in 1939, returned to Ireland.

AS

NORAH MCGUINNESS

1901–80

Village by the Sea

1953
Oil on canvas
68.9 x 91.6 cm
Signed and dated, bottom right,
N. McGuinness 53
Donated by the
Thomas Haverty Trust, 1957
U371

The picturesque fishing village of Dunmore East, Co. Waterford, is the setting for this work. McGuinness was primarily a colourist and the painting is somewhat Fauvist in treatment, in the bright blues, reds and greens and lively handling of paint. The white house in the right background stands out amidst the vivid tones and serves to draw the eye into the picture and along the street towards the church. McGuinness's inclinations were towards the avant-garde and the painting's simplified forms, unorthodox treatment of space and zestful colours transform a highly traditional subject— an Irish village by the sea—into a vibrant and modern image.

Trained in Dublin, McGuinness's first work was as an illustrator and it was not until 1923–24 that she decided to concentrate upon painting rather than illustration. Two years in Paris, between 1929 and 1931, studying under the Cubist André Lhote, gave her experience of Cubism, though she never espoused it fully. She did, however, pursue a rudimentary form of the style at times. In 1939 she returned to Ireland after several years in London and settled in Dublin. A founder member of the Irish Exhibition of Living Art in 1943—an event supportive of Modernism—she became its President in 1944 and remained so until 1972. She did much for the development of avant-garde art in Ireland through her Presidency.

EB

DEREK HILL

1916–2000

Tory Island from Tor More

1958–59
Oil on canvas
71.3 x 122.3 cm
Purchased 1961
U299

Undoubtedly Hill's masterpiece, this landscape was painted from the top of the 'anvil' on Tor More, an outcrop of rock at the easternmost end of Tory. With the entire island laid out below and the light glittering on the sea, the scene conveys the beauty of nature in all its grandeur. The lowish tones of browns, greys and greens, contrasting with the white of the waves, convey the atmosphere and weather. Hill favoured a horizontal composition for his landscapes, which allowed for the distant horizons and low skies he so loved. This format has been used to great effect here. As with many of his Tory views, the work has a lonely and melancholic quality.

A landscape and portrait painter from Southampton, Hill purchased a house in Donegal in 1954 and two years later, paid his first visit to Tory Island, off the Donegal coast. The appeal of the place was immediate. Thereafter, he painted numerous scenes of the island and its inhabitants. He also encouraged the locals to paint, an endeavour which led to the formation of the Tory Island school of painters. Whilst his portraits brought him considerable renown, landscape remained his favourite subject matter. His views of Tory, his spiritual home, have a particular poignancy and beauty.

EB

**TERENCE PATRICK
FLANAGAN ('TP')**
b.1929

Gortahork (2)

1967
Oil, acrylic on board
92.2 x 118.9 cm
Signed bottom right,
T. P. Flanagan
Purchased 1969
U549

Gortahork (2) belongs to a set of paintings collectively entitled *Boglands*. The work was composed from drawings of beaches in the Gortahork area of Co. Donegal, sketched in the autumn of 1966. Flanagan has described it as 'a sort of collage of impressions unified in one space, held together by deliberate linear divisions',[16] his hope being that the viewer would 'read' the picture section by section. The painting's heavy dark forms and general earthy tones are the result of his decision to move towards more simplified shapes and a restricted colour range, changes he considered necessary to convey the rugged Donegal landscape. Elements in the picture are immediately 'readable': the reflections of the autumn light and the rocky hills on the horizon. An atmosphere of stillness and mystery pervades the painting.

One of the most important landscape painters in Ireland in the second half of the twentieth century, Flanagan's work has evolved through the deployment of themes, a technique which has allowed him to experiment with different approaches to a subject. His main aim is to communicate his feelings about the landscape, thus getting to know an area, of 'experiencing' it, is vital to him. His own special places are Fermanagh, Donegal and Sligo.

EB

BASIL BLACKSHAW

b.1932

The Field

1953
Oil on board
71.7 x 91.1 cm
Signed and dated, top left,
Blackshaw 53
Purchased 1955
U238

The field of the title backed on to the Blackshaw family home at Boardmills, Co. Down and was a place Blackshaw knew well; as he said of it, he 'loved and lived in it and beagled in it after hares'.[17] Executed with an Expressionist use of brushwork and colour to indicate the stubble of cut corn, the picture is one of a related group dating from the first half of the 1950s to explore fields and roads. Blackshaw's fondness for 'the field' is allied to a fundamental characteristic of his art – his need to be *connected* with a landscape and his unwillingness to paint a view simply for the sake of it.

Rural subjects like the land, horses and dogs have always figured prominently in Blackshaw's output, for he has been a country dweller all his life. Trained at Belfast College of Art, he had his first one-man show in 1955 – at which exhibition this picture was purchased. Though his style has changed considerably over the years, from the figurative paintings of the 1950s, '60s and '70s to the simplified shapes and occasional semi-abstraction found in works produced from the 1980s, two elements have remained constant in his art: his expressive use of paint and his need to explore a theme in depth. This approach has enabled him to pursue and tease out, in a spontaneous unplanned way, nuances which fascinate him.

EB

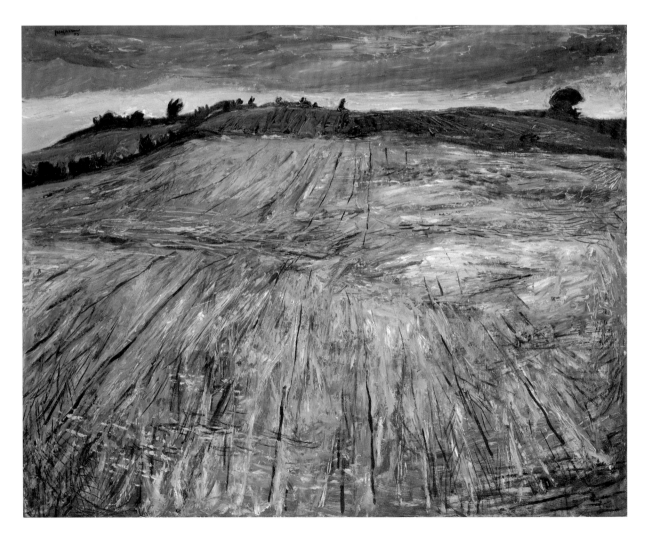

BASIL BLACKSHAW

b.1932

The Barn (Blue II)

1991–92
Oil on canvas
50.8 x 61 cm
Signed top right,
Blackshaw
Purchased 1992
U4942

Blackshaw's expressive use of paint is fundamental to his art. He has always worked in a free, 'painterly' manner, placing emphasis on the act of painting and making play with his materials, so that strong colours and obtrusive brushwork are characteristic features of his works. This is powerfully evident here, in the vibrant blues and thick wodges of greys, oranges and whites, colours and textures inspired by seeing a barn somewhere between Loughbrickland, Co. Down and Poyntz Pass, Co. Armagh.

Responding emotionally to a thing seen or remembered is crucial to his creativity; as he said of *The Barn (Blue II)*, he 'didn't know why he painted [the barn] blue. That's the mystery of painting—a mundane thing clicks and becomes an image. A painterly image grows inside you … the subjects are a mystery … The barn was a dingy old place'.[18] This stirring of the imagination from remembered flashes, is pivotal to his art. One of the most influential painters in the north of Ireland, his work is strongly autobiographical.

EB

WILLIAM SCOTT

1913–89

Still-Life

1949
Oil on canvas
57.5 x 66 cm
Signed bottom left,
W. Scott
Purchased 1978
U2475

William Scott is recognised as one of the foremost abstract painters of his generation. His development was slow and deliberate as he relentlessly pared away the figurative aspects of his work to reveal underlying pure form. Using the traditional elements of still-life painting he explored the abstract qualities of domestic objects, placing them on the picture surface with great sureness. By the late 1940s he had largely rejected the restrictions of figurative painting and stated that he 'longed for a freedom from the object'. In *Still-Life* his flattening of the three-dimensional elements of the composition transforms the small bright plums and rich brown coffee within the cup into pure abstract shapes.

Scott was born at Greenock, Scotland, the eldest of eleven children. In 1924 his father, a sign-painter, returned with his family to his native Enniskillen. When, three years later, Scott's father died in a tragic accident a scholarship enabled Scott to study at the Belfast School of Art and in 1931 he entered the Royal Academy Schools. In 1937 Scott travelled abroad, settling at Pont-Aven where he met artists who had known Gauguin. After the war he re-visited Brittany and resumed his exploration of the French tradition of still-life painting in the work of Chardin, Cézanne and Braque.

AS

WILLIAM SCOTT
1913–89

Brown Still-Life

1958
Oil on canvas
89.5 x 99 cm
Purchased 1958
U404

In 1958, the year he painted *Brown Still-Life*, Scott was commissioned to work on a vast mural, forty-six feet long, for Altnagelvin Hospital in Derry. As a result of working on this scale the abstract quality of his painting developed a new sense of poise and monumentality. In his subsequent painting Scott introduced abstract shapes that are cut by the edge of the canvas, giving the impression that they may form part of a larger work. In *Brown Still-Life* he employed an austerely limited tonal range of brown, black and grey to accentuate the newly-simplified abstract shapes of the saucepan and bowl.

In 1953 Scott travelled to New York where he was impressed by the raw vitality of Abstract Expressionism and in particular the work of Rothko and Jackson Pollock, both of whom he met. The visit, however, reaffirmed his links with the European tradition of Chardin and Cézanne and strengthened his belief in the importance of line and composition. In 1954 he visited the Lascaux caves and was fascinated by the latent power of the pre-historic animal paintings recently discovered there. The experience revived his interest in Primitivism and the energy and eroticism that can be suggested by the placing of abstract forms.

AS

WILLIAM SCOTT
1913–89

Whites

1964
Oil on canvas
185 x 122 cm
Signed and dated, on reverse,
W. Scott 64
Purchased 1983
U2663

Whites marks a point in Scott's career when his painting assumed a high degree of abstraction. The work has a powerful sense of formality and restraint and represents the reduction of the still-life elements in his work to their simplest form. The picture is created by using subtle gradations of white and taut outlines to suggest the underlying shapes of domestic objects. The minimalist form of the work and the concentration on a single colour show, in part, Scott's response to the work of Rothko. In the early months of 1964, when *Whites* was painted, Scott was working in Berlin as a Ford Foundation artist-in-residence. At that time he was experimenting with the placing of shapes at the edge of the canvas, an idea deriving from his Altnagelvin mural of 1958–61.

During the 1960s Scott developed an austere form of abstraction based on pure forms and a sensuous handling of paint. As his work became more abstract so his brushwork came to play a greater role in heightening the expressive power of his painting. Later in his career he moved between abstraction and figurative painting and produced a remarkable series of nudes based on his deep admiration for Bonnard.

AS

CAMILLE SOUTER

b.1929

The Last of the Radicio

1964
Oil on paper on board
58.2 x 78.5 cm
Signed and dated, bottom right,
Camille Souter 1964
Purchased 1965
U704

In *The Last of the Radicio,* Souter depicts a small farm near Chioggia, on the sandy shores of the Venetian Lagoon. The only remaining crop on the land is the dark red radicchio, a form of chicory widely grown in the Veneto. Souter had visited Chioggia ten years earlier, when all the fields had been full of radicchio and she described how, on her return, new roads and hotels had swept away much of the local agriculture. Souter returned to the farm where she had once stayed and was saddened to find 'all had that forlorn look that massive building projects give to the surrounding soil'.[19] The work is pervaded by a sense of loss and nostalgia, as only a few radicchio plants remain and the small farm now appears isolated and threatened.

A highly instinctual and original artist, Souter was born in Northampton and came to Ireland as a child. After the war, she trained as a nurse at Guy's Hospital and during her convalescence from tuberculosis, taught herself to paint. Born Betty Pamela Holmes, she adopted the name Camille soon after she met her first husband, Gordon Souter. Influenced by post-war European painting and American Abstract Expressionism, her work is characterised by a questing emotional urgency.

AS

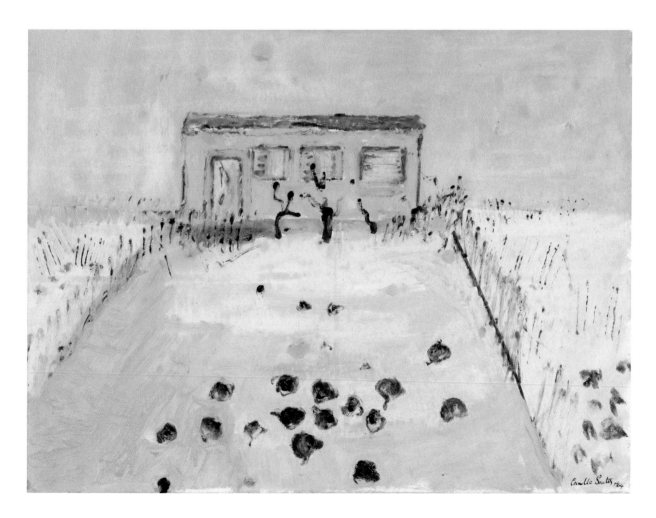

PATRICK SCOTT

b.1921

Yellow Device

1962
Tempera on canvas
96.7 x 81.5 cm
Signed and dated, bottom right,
Scott 62
Purchased 1962
U703

In *Yellow Device* Scott applied spots of pure colour onto raw canvas, allowing the paint to soak in and create the impression of an exploding bomb. In 1962 a number of high profile nuclear tests had been carried out around the world including the 'Rainbow Bomb', so called because of the colours released by the explosion into the upper atmosphere above the Pacific. As a protest against these tests, and the use of the seemingly innocent term 'nuclear device', Scott made a series of paintings, each containing the word 'device' in the title. This series played an important part in his shift towards pure abstraction and marked the beginning of his preoccupation with circles and spheres.

By the end of the 1960s he had largely abandoned colour in his painting and instead used gold-leaf applied to unprimed canvas to create abstract works of great power and simplicity.

Scott trained as an architect and was largely self-taught as an artist. Early in his career he exhibited with the White Stag Group and in 1960 represented Ireland at the Venice Biennale. His travels in China and Japan strengthened his interest in oriental forms and practices and contributed to his development as an abstract painter.

AS

MICHEAL FARRELL

1940–2000

Pressé Series with Cream

1970
Acrylic on canvas
122.4 x 122 cm
Signed and dated on
reverse, top right,
Micheal Farrell 1970
Purchased 1970
U723

During the 1960s Farrell developed a highly distinctive style of Hard Edge abstraction, drawing influences from Celtic decoration and the bold outlines and flat colours of Pop art. *Pressé Series with Cream* is part of a major series that evolved in the aftermath of the student riots in Paris of 1968. Farrell had observed the way citron pressé, a Parisian café drink, is made by the pounding of lemons between pestles and used this simple motif to represent the harsh cruelty of political oppression. By 1970 he adapted the Pressé motif to refer to the increasing civil unrest in Northern Ireland and coloured the arabesques of spurting juice to indicate spilt blood and political allegiance.

Born in Co. Meath, Farrell was educated at Ampleforth and St Martin's School of Art in London. During the early 1960s he remained in London, where he was associated with David Hockney and Patrick Caulfield. In 1966 he was awarded a scholarship to study in New York and in 1971, settled in France. By the mid-1970s his work had become largely figurative, most notably when he painted a highly personalised version of Boucher's *Resting Girl* as *Madonna Irlanda or The Very First Real Irish Political Picture*, 1977 (Dublin City Gallery The Hugh Lane).

AS

BARRIE COOKE
b.1931

Big Tench Lake

1972
Oil on canvas, diptych and
perspex box
Canvas 183.2 x 304.8 cm
Signed and dated, bottom right
of right-hand canvas,
Barrie Cooke 72
Purchased 1974
U2287

Cooke is best known for his sensuous and
resonant paintings inspired by the bog lands,
rivers and wild places of Ireland. His work is
deeply rooted in the natural world and makes
reference to native natural history and Celtic
mythology. *Big Tench Lake* is painted on two
canvases joined by an abstract motif of gold
leaf, reminiscent of the flash of a fish or a
Bronze Age clasp. Central to the work is Cooke's
intention to illustrate the ever present growth
and change in nature, which he describes as
the 'metamorphosis–of water into weed, of
weed into fish, fish into stone'.[20] The theme of
metamorphosis is continued in a small perspex
box placed before the painting, containing the
suspended forms of ceramic leaves.

Born in Cheshire, Cooke grew up in Bermuda
and the United States, where he studied marine
biology and art history at Harvard. In 1954 he
settled in Ireland and throughout his career
his passionate enthusiasm for fishing has
contributed to his strongly emotive response
to the Irish landscape. This response has been
valued by poets with similar interests and Ted
Hughes was a long-standing fishing companion.
In 1972 Seamus Heaney dedicated a poem,
'Cairn-maker' to Cooke, who later illustrated
Heaney's *Bog Poems* (1975).

AS

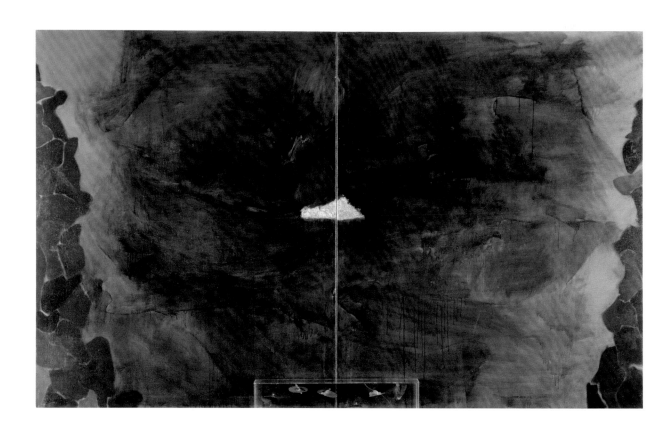

SEAN SCULLY

b.1945

Fourth Layer, Tooley Street

1973
Acrylic on canvas
244 x 244 cm
Signed and dated on reverse,
Sean Scully 73
Purchased 1974
U2079

Fourth Layer, Tooley Street is one of a series of works Scully made in the early 1970s which reflect his interest in the creation of depth and surface texture in abstract painting. The title refers to the complex layering of colour and to a disused building in Tooley Street, which he used as a temporary studio. The building overlooked London Bridge Station and the room where he worked had a gaping hole several floors deep resulting from years of seeping rain water. The ordered structure of the painting was, as Scully recently observed, an attempt to impose control on a chaotic space.

Born in Dublin, Scully is recognised as a major figure in the development of twentieth-century abstract painting. His early work emerged from his experiences of the stark industrial landscape of Newcastle-upon-Tyne (where he studied 1968–72) and from his interest in light and colour, triggered by a visit to Morocco in 1969. In 1972-73 Scully spent a year as artist-in-residence at Harvard University and the light and scale of East Coast America profoundly affected his work. He uses a simple abstract form, the stripe and for over three decades has explored and expanded this motif to create abstract paintings of great power and physical presence.

AS

EDWARD MCGUIRE

1932–86

Portrait of Seamus Heaney
(b.1939)

1974
Oil on canvas
142 x 112.1 cm
Signed and dated, bottom right,
Edward McGuire 74
Commissioned by the
Ulster Museum, 1973
U2107

McGuire's portrait of Heaney was commissioned early in the poet's career, when he was thirty-four. Other portraits followed but this remains the definitive image and there is in the pose, a sense of suppressed urgency and intent. Heaney later spoke of McGuire perceiving in him 'a keep of tensions' and that 'the gathered-up, pent-up, head-on quality is what I admire'[21] in the portrait. McGuire often included symbolic objects in his portraits and, like Holbein, they are meticulously painted and sometimes difficult to decipher. The birds and foliage outside the window, described by Heaney as 'his own kind of phantasmagoria'[22] seem, however, not to have a symbolic meaning beyond the poet's deep connection with nature. Originally a bowl of chestnuts was to have been included but McGuire abandoned the idea and Heaney recorded their lost presence in a poem 'The Basket of Chestnuts' (1991).

Born in Dublin, McGuire studied at the Slade School in London under Lucian Freud. In 1955 he returned to Dublin and for the rest of his career, made a remarkable series of portraits of writers, musicians and friends. Seamus Heaney, born near Bellaghy, Co. Derry, is widely acknowledged as one of the greatest poets of the twentieth century. In 1995 he was awarded the Nobel Prize for Literature.

AS

NEIL SHAWCROSS

b.1940

Portrait of Francis Stuart
(1902–2000)

1978
Oil on canvas
122 x 92 cm
Signed and dated, bottom right,
Shawcross 1978
Commissioned by the Ulster
Museum, 1978
U2474

A blank background and absence of detail is a major characteristic of Neil Shawcross's portraits; for him, isolating his sitter as if on an empty stage helps reinforce the person's directness with the viewer. Other characteristics include simplified shapes and paint applied loosely in wide swathes. These traits are plain to see in this portrait of the Irish novelist and playwright Francis Stuart, best known for *Black List, Section H* (1971), in the splodges of colour which form his face and in the naïve, almost childlike rendering of his body. Stuart's rabbit and cat were significant symbols in his writing, hence their inclusion.

A lecturer at Belfast College of Art (now subsumed into the University of Ulster) from 1962 until 2004, Shawcross has also had a distinguished career as an artist. His simplicity of image is an approach he adopted many years ago when teaching children; their simplicity became his, as he divested himself mentally of years of training in Bolton and Lancaster, to view the world afresh. Stripped thus, he could concentrate on his major interest—paint. Besides portraits, his output embraces still-life, flower pieces and the female nude. Whatever the subject, however, his primary concern remains his medium; for him, art will always be about exploring exciting uses of paint.

EB

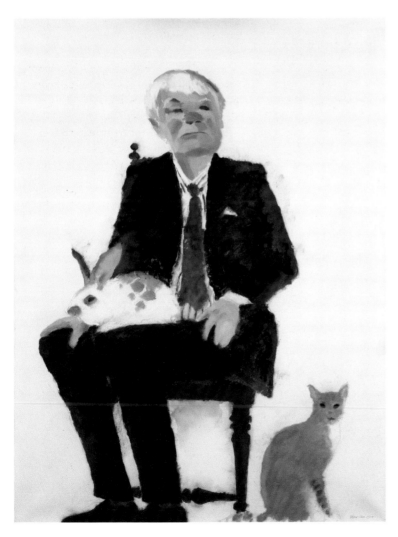

CAROL GRAHAM

b.1951

Light Falls Within

1978
Oil, acrylic on canvas on board
64.8 x 74.9 cm
Signed and dated, bottom right,
Carol Graham 6/78
Purchased 1978
U2506

Light Falls Within is one of a series Carol Graham painted during the 1970s and early 1980s on the theme of the 'striped skirt'. Such works stemmed from her attraction to things hidden or half revealed. With the skirt series, details within the picture frame are carefully delineated – the folds of the material, a foot, a hand, an arm, a leg – whilst the rest of the woman remains a mystery. Graham said of her paintings in 1981: 'I … wish my work to both challenge and seduce the viewer'.[23] *Light Falls Within* is certainly both enigmatic and spellbinding. Painted in the strongly realist style she espoused at the time, the picture displays her fascination with the effects of light, a continuing theme in her art.

Trained at Belfast College of Art, Graham is one of the best-known artists in the north of Ireland and was President of the Royal Ulster Academy 2004–7. Something of an experimental painter, her work includes commissioned portraits, executed with extreme realism; directly observed landscapes, painted in a freer manner than her realism of the 1970s and 1980s; and intense and deeply personal explorations of the psyche, hewn from a period of depression in the early 1990s. Whilst her art has always been autobiographical, these last works – these 'soundings of psyche' – are particularly honest in content.

EB

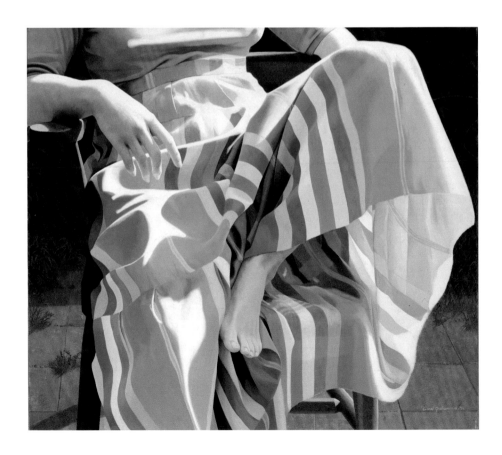

ROBERT BALLAGH

b.1943

Inside No. 3

1979
Acrylic on canvas
177.2 x 178.1 cm
Purchased 1979
U2534

Since the late 1970s Ballagh has made a series of autobiographical paintings recording his life and artistic influences. *Inside No.3* is one of the earliest and depicts the ground floor of the artist's house, No.3 Temple Cottages, near King's Inns, Dublin. Strongly influenced by Pop art, Ballagh confronts the romantic idea of the artist's self-portrait by painting only his shoes and lower right leg as he watches himself on television. The work also makes reference to two 'iconic' paintings particularly admired by Ballagh. A framed detail of *Liberty Leading the People*, 1830, by Eugène Delacroix (Louvre) hangs on the wall and the nude figure of the artist's wife on the spiral staircase alludes to *Nude Descending a Staircase, No.2*, 1912 by Marcel Duchamp

(Philadelphia Museum of Art). By according his possessions the same prominence and careful attention as the art historical references, Ballagh makes the point that all influences are equally relevant to his art.

Born in Dublin, Ballagh originally studied architecture and later trained briefly under Micheal Farrell. He considers himself largely self-taught and is widely known for his many portraits, stamp and bank-note commissions, theatre designs and the dramatic 'Riverdance' sets (1995).

AS

RITA DUFFY

b.1959

Nuptial Grooming

1994
Oil on canvas
122.2 x 122.2
Signed bottom right
Rita Duffy
Purchased 1994
U4984

Nuptial Grooming is an autobiographical painting in which Duffy questions the traditional role and attributes of the bride. Painted when she was artist-in-residence at the Ulster Museum, the work shows the artist struggling to prepare for her marriage. Central to the work is the symbolic wedding dress which threatens to temporarily alter her personality and is already being unravelled by a small child. Duffy's work contains a strong desire to question perceptions of the recent past in Northern Ireland and her direct manner of painting follows in the tradition of Frieda Kahlo and Paula Rego and the biting social criticism of Otto Dix and German Expressionism.

Born in Belfast, Duffy studied at the Belfast College of Art and has worked both as a theatre set designer and street artist. Her work deals with Belfast life and draws on the oral traditions of society and industry and the experience of the Troubles. These interests have led to her involvement in community arts projects and a series of public art commissions. More recently, she has considered the legacy of the Titanic, producing powerful images based on the motif of the iceberg. In recognition of this series, Paul Muldoon dedicated a poem, 'Leadheads and Icebergs' (2005), to her.

AS

FELIM EGAN

b.1952

Line Composition – Blue

1979
Acrylic on canvas
147.5 x 147.5 cm
Signed and dated on
reverse, top right,
Felim Egan 79
Purchased 1979
U2523

An abstract painter of great purpose and assurance, Egan's work is characterised by sparse purity of form. *Line Composition-Blue* is an early example of his interest in the variations and symmetry of musical notation. An impression of compressed energy can be found in the deft arrangement of curved and angular lines and the gradation between light and dark suggests the harmony and dissonance of musical composition. In recent years, an understanding of landscape has influenced Egan's work and his daily awareness of the low horizon and limpid skies of Sandymount Strand, near Dublin, where he lives, has introduced a sense of atmospheric stillness to his painting.

Born in Strabane, Co. Tyrone, Egan studied in Belfast and Portsmouth and at the Slade School in London. In 1979 he was awarded a scholarship to the British School in Rome. Primarily a painter, he has worked extensively on paper, producing watercolours and prints of particular delicacy. He is deeply interested in the craft of picture making and considers the stretching of canvas and preparation of paper as an integral part of the creative process. Egan has collaborated with Seamus Heaney, providing illustrations for *Squarings* (1991) and *Sandymount Strand* (1993).

AS

ANNE MADDEN
b.1932

Le Jardin

1988
Oil on canvas, diptych
127 x 178 cm
Purchased 1990
U4808

A poetic painter, Madden is drawn to subjects conveying the powerful forces she finds in myth and the natural world. During her adolescence, she spent long periods in the Burren area of Co. Clare and that experience confirmed her affinity with wild and desolate places. In the early 1970s she made a series of 'megalith' paintings based on the Stone Age tombs of the Burren, to 'seek out the symbolic order and hidden secrets of the… Burren of my youth'.[24] In later years, windows and openings into hidden places became recurrent motifs in her painting.

In *Le Jardin* Madden depicts the gardens surrounding her studio at Les Combes, in the south of France. The stairs and dark recesses have a theatrical dream-like quality that is intensified by the deep inkiness of the night sky and piercing brilliance of the moonlight. The work is also an evocation of memory and the poetic symbolism she perceives in long familiar places. Born in London, Madden grew up in Chile and during the mid-1950s, studied at the Chelsea College of Art. In 1958 she married the painter Louis le Brocquy and together they settled at Les Combes, where they lived for many years, returning to Ireland in 2000.

AS

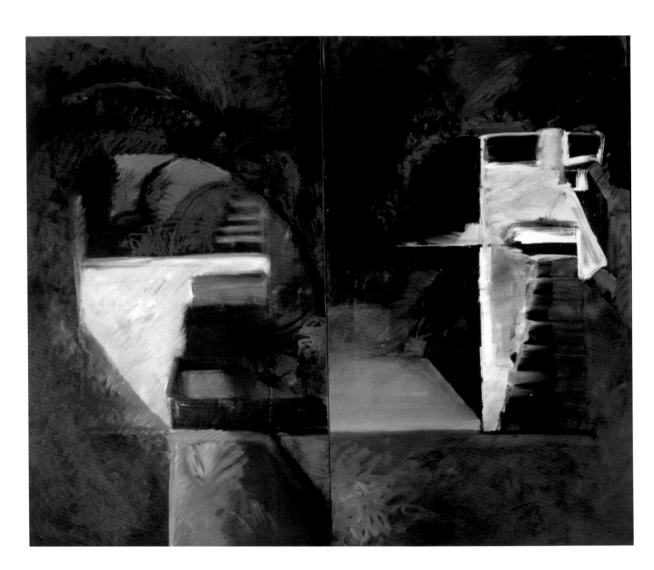

ELIZABETH MAGILL

b.1959

Chronicle of Orange

2007
Oil on canvas
153 x 183 cm
Purchased 2009
U5158

Chronicle of Orange is a complex and arresting work in which Magill challenges the conventional traditions of Irish landscape painting. The place and season, even the time of day or night, are blurred, so creating a sense of disorientation and unease within a familiar landscape. Since the late 1990s, Magill has evolved a highly distinctive manner of working which begins with marking and staining the canvas. The resulting fissures and pools of colour become the basis for her landscapes, which are built up through the repeated application of layers and glazes of pigment. This process is apparent in *Chronicle of Orange,* in which an orange mist, resembling the sodium luminescence of street lighting, is made to pervade the landscape. In her work, objects as familiar as a telegraph pole or hedgerow foliage can appear altered and menacing.

Born in Ontario, Canada, Magill spent her childhood in Co. Antrim. Between 1979 and 1984 she studied at the Belfast College of Art and the Slade School in London. Influenced by the European tradition of Romantic painting, she is best known for her ability to infuse unremarkable, often suburban, landscapes with a sense of the tension she perceives between the man-made environment and the elemental forces of nature.

AS

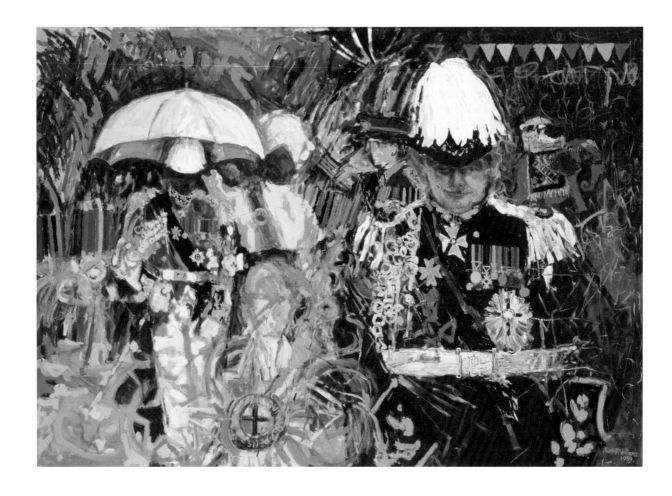

JOSEPH MCWILLIAMS
b.1938

The Governors of Anguilla,
Gibraltar, the Caymen Islands
and the Last Governor of
Northern Ireland

1989
Oil on canvas
152.3 x 213.4 cm
Signed and dated, bottom right,
Joseph McWilliams 1989
Purchased 1989
U4805

The Governors … , a colourful and extravagant
spectacle, is a somewhat tongue-in-cheek
comment by McWilliams on the culture of
colonialism and the imperial trappings around
it: the Garter insignia, plumed hats, medals
and elephant with Governor on its back (top
right). The last Governor of Northern Ireland,
Lord Grey of Naunton, in office from 1968 to
1973, dominates the foreground, resplendent
in his regalia. Executed in an Expressionist
manner, with rapid brushstrokes, lush paint
and liberal use of vibrant reds and yellows, the
picture seems to exude an air of official bustle
and obeisance to rank, in the turbaned servant
shielding one of the Governors from the sun and
the soldier saluting in the background.

Ever since his student days at Belfast College
of Art, McWilliams's art has had a political
dimension. A chronicler of events around him,
much of his subject matter has been drawn
from the Troubles in Northern Ireland. Such
works, however, are observations and never
judgmental. One of his favourite themes
is parades, whether loyalist, nationalist or
religious. The Twelfth, in particular, he has
painted many times, in lively and colourful
scenes which capture exactly the spirit of the
event. A past President of the Royal Ulster
Academy, he is also a frequent broadcaster and
lecturer on the visual arts in Northern Ireland.

EB

DAVID CRONE
b.1937

By Railings

1991
Oil on canvas
140 x 275 cm
Purchased 1991
U4890

Despite taking a near-abstract approach, David Crone is not an abstract painter; there is always some recognisable imagery within his work. In *By Railings,* the shape of a person can be seen to the right, whilst a head and a hand are distinguishable to the left. Crone's paintings, from about 1975 until the mid-1990s, dealt with the urban scene and people going about their daily routine: shopping, socialising, taking part in the business of living. Such is the context of *By Railings.* Painted with an Expressionist verve, the picture seems to capture the dynamism of city life, being full of movement, of snatches of things glimpsed until the eye finally focuses upon the figure to the right. The lively colours emphasize the animation of the scene and are characteristic of Crone's work at the time.

Crone's early interest was landscape and his adoption of the city as subject matter in 1975 came about when he began working in the centre of Belfast, lecturing at the Art College (later part of the University of Ulster). Since moving to the country, to Spa near Ballynahinch in 1994, he has returned to his first love: landscape and nature. An academician of the Royal Hibernian Academy, he is one of the most significant artists working in Northern Ireland today.

EB

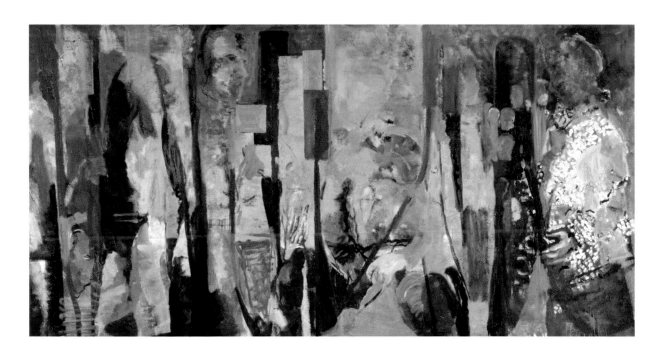

CIARÁN LENNON

b.1947

Scotoma II/H

1992–93
Oil on canvas
243.8 x 365. 6 cm
Purchased 1993
U4959

An abstract painter of intellectual rigour, Lennon has long been interested in Italian Renaissance paintings of the Annunciation. In many of these works, the central and most mysterious aspect of the story, the light from the Holy Spirit, is not actually shown. Lennon's response to this unseen element was the Scotoma series of paintings, which he describes as representing 'in a profane and secular sense my version of the Annunciation theme in early Renaissance art'.[25] Scotoma is a medical term signifying a blind spot in an otherwise normal field of vision. Lennon chose this title to refer to what is unseen in painting but can, none the less, be deeply felt and understood.

Born in Dublin, Lennon was influenced during his early career by Cézanne's clarity of form and the spiritual use of colour he perceived in Rothko. In the Scotoma paintings, the sombre surface colours of dark blue and purple are under-painted with richer colours, giving a sense of inner intensity. The pale area at the top of the painting is reminiscent of a high window though which light can enter, as in an early Renaissance Annunciation scene.

AS

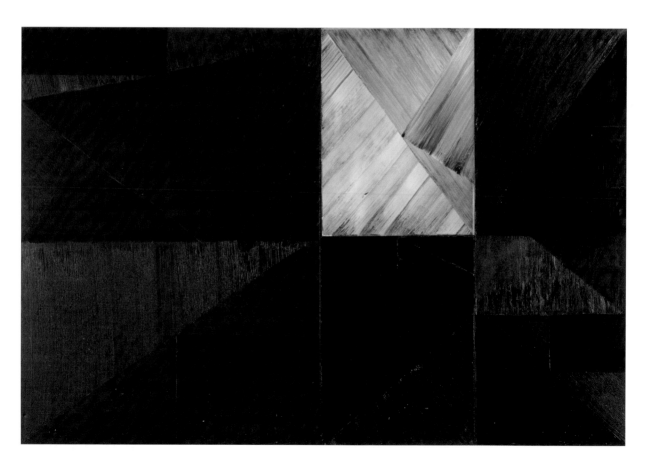

MARK FRANCIS

b.1962

Negative (IV)

1994
Oil on canvas
180 x 180 cm
Donated by the Contemporary
Art Society, 1996
U5036

Originally a landscape painter, Francis became increasingly interested in the structures and movements of microscopic organisms, perceiving a new form of landscape viewable only with scientific instruments. *Negative (IV)* is part of a series of monochrome paintings made during the mid-1990s, using abstract shapes deriving from his study of botany and anatomy. The small dark forms have the character of pollen grains or sperm heads and appear as if caught and held on a microscope slide. Their paths are delicately painted in tones of grey, suggesting that the traces and echoes of their movements have been captured by ultrasound or X-ray negative.

Born in Newtownards, Co. Down, Francis studied in London at St Martin's School of Art and later, at the Chelsea College of Art. His painting is influenced by Gerhard Richter's deliberate imitation of photographic effects and the exuberant enjoyment of abstract forms he finds in the work of Klee and Miró. Francis is increasingly viewed as having introduced a new direction in abstract painting, through his highly original questioning of traditional perceptions of the scientific world.

AS

HUGHIE O'DONOGHUE

b.1953

Wrestlers

2000–2
Oil on canvas, triptych
240 × 522 cm
Purchased with the aid of
grants from the Art Fund and
the Esmé Mitchell Trust, 2004
U4490

Wrestlers was begun when O'Donoghue was artist-in-residence at St John's College, Oxford and relates to the experience of the Allied armies in Italy during the closing stages of the Second World War. The composition derives from an antique sculpture of wrestlers unearthed in Italy during the sixteenth century and the figures have the tonality of long-buried and patinated marble. Incorporated into the work is an image, derived from a photograph, of a soldier digging a howitzer gun out of the mud at Monte Cassino in 1944. For O'Donoghue, this image represents his own attempt to unearth meaning from historical events and acts as a symbol of the futility of war. The word *Roma*, inscribed on the painting, pays homage to the overpowering historical presence of that city and the hard fought campaign to recapture it.

Born in Manchester, of Irish descent, O'Donoghue is best known for his exploration of the human figure in relation to the themes of history, myth and war. His paintings, often monumental in scale, are built up through a complex layering of paint to produce colours and surface textures of great subtlety. Central to O'Donoghue's work is his desire to express the individual's experience of war and the process of memory.

AS

HECTOR MCDONNELL

b.1947

Ground Zero, September 2001

2002
Oil on canvas
72 x 48 cm
Donated by the Friends of the
Ulster Museum, 2004
U5135

On the morning of 11 September 2001, two
hijacked jet airliners were flown into the 'Twin
Towers' of the World Trade Centre in New York,
as part of a carefully-orchestrated terrorist
attack on the United States. Almost instantly
the events were watched around the world and
the subsequent speed with which the towers
collapsed and the shocking loss of life made
the tragedy difficult to comprehend. Less than
two weeks after the disaster, McDonnell visited
'Ground Zero' and wrote: 'the acrid smell,
taste, and sensation of burnt building and
dust, reawakened hideously vivid memories
of Belfast in its worst times, in the 1970s, when
I wandered its streets trying to find a way of
speaking about that disaster'.[26]

Born in Belfast, McDonnell is a superb
draughtsman and a painter of great skill and
perception. His manner of painting owes much
to the tradition of Manet and Orpen and he is
often at his most accomplished when depicting
the interiors of bars and cafés. He has travelled
extensively and brings acute observation and
erudition to unfamiliar and exotic scenes. His
most affecting work remains that of the places he
knows most intimately, in particular New York
and his native Co. Antrim.

AS

WILLIE DOHERTY

b.1959

Apparatus

2004–5
40 cibachrome prints
on aluminium
Consisting of eight sets
of five photographs, each
photograph 56 x 70 cm
Edition of six (6/6)
Purchased with the aid of a
grant from the Art Fund, 2007
U5155

Born in Derry, Doherty has established an international reputation as one of the leading artists currently working in photography and video. From 1978 to 1981 he studied sculpture at the Ulster Polytechnic and since the early 1980s, has consistently addressed themes of surveillance, territoriality and identity. Twice nominated for the Turner Prize (in 1994 and 2003), he has represented Ireland and Northern Ireland at the Venice Biennale (1993 and 2007) and the United Kingdom at the São Paulo Biennale (2002).

Apparatus is a series of forty images relating to Belfast, mainly of the disregarded places close to the 'peace-lines'. Made during 2004-5, at a time when the threat of sectarian violence was immediate, the work forms part of Doherty's wider exploration of the uninhabited marginal places that exist in cities. Central to Doherty's work is the apparent contradiction between a sense of danger and unease and the physical beauty that he perceives in the traces of past violence and neglect. In *Apparatus*, the powerfully composed images alternate between surfaces scarred by unspecified forces and the fragility of foliage in places where nature encroaches.

AS

WILLIE DOHERTY
b.1959

Ghost Story

2007
15 minutes looped video
installation
Edition of three (3/3)
Purchased with the aid of a grant
from the Esmé Mitchell Trust,
2008
U5154

First shown at the 52nd Venice Biennale in 2007, where Doherty represented Northern Ireland, *Ghost Story* is a powerful and complex video installation which draws together the most important themes and directions in his work to date. Doherty uses sound and projected images to address the processes of memory and the hold of past fears and experiences on the present. Central to the work is a view of a country road stretching between dark woods. Doherty's text, spoken by the actor Stephen Rea, evokes oral storytelling and suggests possible interpretations of the fractured images which break into the landscape like flashes of memory. *Ghost Story*

moves between dark and light, urban and rural, faces caught in full light and anonymous figures lost in shadow, memories of the recent past and folk superstitions about death. The images shift between the actual and the remembered, leaving the viewer unsure and challenged about the events described.

Doherty's practice has been conditioned by an experience of the Troubles. In *Ghost Story* the landscape triggers memories and holds secrets from the past, resulting in a new interpretation of the tradition of landscape in Irish art.

AS

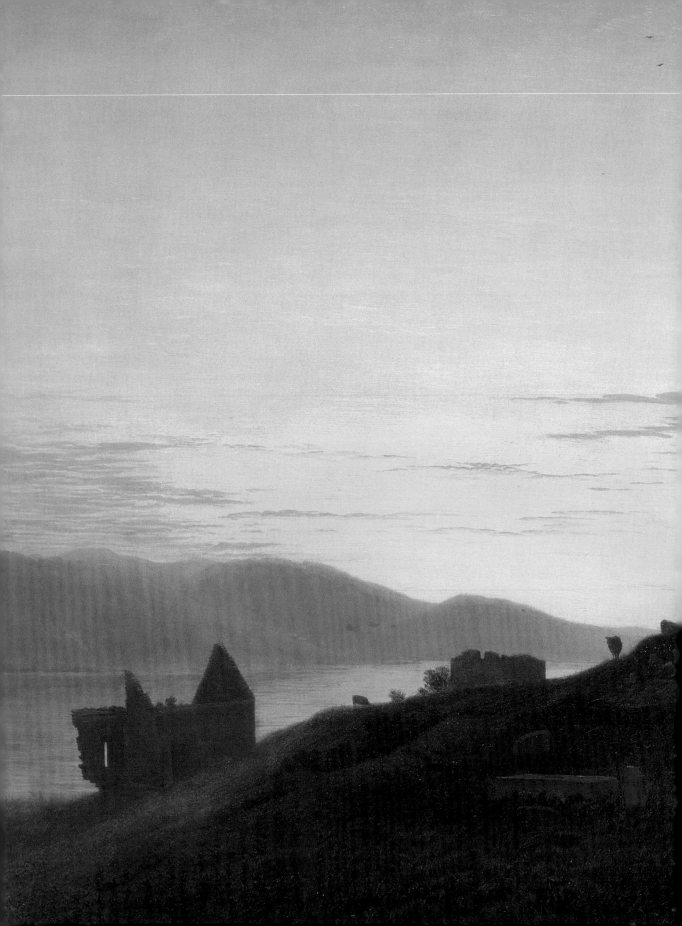

NOTES

1 Crookshank and Glin, *Ireland's Painters,* pp. 19, 65.

2 Crookshank and Glin, *Ireland's Painters,* p. 134.

3 Black, *Art in Belfast 1760-1888,* pl. 2.

4 Crookshank and Glin, *Ireland's Painters,* p. 155.

5 Crookshank and Glin, *Ireland's Painters,* p. 165.

6 Crookshank and Glin, *The Painters of Ireland,* p. 143.

7 Cullen, 'The Oil Paintings of Hugh Douglas Hamilton,' *The Walpole Society,* vol. L, 1984, pl. 96.

8 Hutchinson, *James Arthur O'Conor* exhibition catalogue, Dublin, Belfast, Cork, November 1985 – April 1986, no. 77 and illus. 19.

9 Crookshank and Glin, *Ireland's Painters,* p. 196.

10 Pyle, *Yeats: Portrait of an Artistic Family,* p. 30.

11 Crookshank and Glin, *Ireland's Painters,* p. 292.

12 Hewitt, *John Luke (1906-1975),* p. 58.

13 *Ireland's Painters,* p. 299.

14 Letter from Hilda Roberts, 16 February 1977 (Ulster Museum records).

15 Hall, *Colin Middleton: A Study,* p. 10.

16 Letter from T. P. Flanagan, 6 December 1976 (Ulster Museum records).

17 Notes of a conversation between Basil Blackshaw and S. B. Kennedy, 31 May 1976 (Ulster Museum records).

18 Notes of a conversation between Basil Blackshaw and Eileen Black, 16 April 2002 (Ulster Museum records).

19 Letter from Camille Souter, April 1977 (Ulster Museum records).

20 Notes from Barrie Cooke per the David Hendriks Gallery, Dublin, 23 September 1974 (Ulster Museum records).

21 O'Driscoll, *Stepping Stones: Interviews with Seamus Heaney,* p. 329.

22 Fallon, *Edward McGuire, RHA,* p. 55.

23 *Carol Graham* exhibition catalogue, Belfast, Arts Council Gallery, December 1981 – January 1982, p. 1.

24 *Anne Madden* exhibition catalogue, Dublin, Irish Museum of Modern Art, June – September 2007, p. 19.

25 Letter from Ciarán Lennon, 26 April 1993 (Ulster Museum records).

26 Notes from Hector McDonnell on the occasion of the *Hector McDonnell* exhibition, Ulster Museum, December 2003 – March 2004 (Ulster Museum records).

SELECT BIBLIOGRAPHY

Books

Martyn Anglesea, *The Royal Ulster Academy of Arts: A Centennial History* (Belfast: The Royal Ulster Academy of Arts, 1981).

Martyn Anglesea, *William Conor: The People's Painter* (Antrim: W. & G. Baird Ltd. in association with the Ulster Museum, 1999).

E.H.H. Archibald, *Dictionary of Sea Painters* (Woodbridge, Suffolk: Antique Collectors' Club, 1980).

Bruce Arnold, *Orpen: Mirror to an Age* (London: Jonathan Cape, 1981).

Bruce Arnold, *Jack Yeats* (New Haven and London: Yale University Press, 1998).

Jonathan Bell, *Conor: Drawing from Life* (Belfast: Appletree Press, 2002).

Eileen Black, *A Catalogue of the Permanent Collection: 3: Irish Oil Paintings, 1572-c. 1830* (Belfast: Ulster Museum, 1991).

Eileen Black, *A Catalogue of the Permanent Collection: 4: Irish Oil Paintings, 1831-1900* (Belfast: Ulster Museum, 1997).

Eileen Black, *Derek Hill (1916-2000): A maestro of portraiture … A master of landscape* (Antrim: The W. & G. Baird Group in association with the Ulster Museum, 2002).

Eileen Black (ed.) (Essay by Liam Kelly), *Neil Shawcross: Forty Years of Portrait Painting* (Belfast: The Blackstaff Press and the National Museums and Galleries of Northern Ireland/Ulster Museum, 2005).

Eileen Black, *Art in Belfast 1760-1888: Art Lovers or Philistines?* (Dublin and Portland, Or: Irish Academic Press, 2006).

David Carrier, *Sean Scully* (London: Thames and Hudson, Ltd., 2004).

Mike Catto, *Art in Ulster: 2* (Belfast: Blackstaff Press, 1977).

Garrett Cormican, *Camille Souter: The Mirror in the Sea* (Dublin: Whyte's, 2006).

Anne Crookshank and The Knight of Glin, *The Painters of Ireland c. 1660-1920* (London: Barrie & Jenkins, 1978).

Anne Crookshank and The Knight of Glin, *Ireland's Painters 1600-1940* (New Haven and London: Yale University Press, 2002).

Tom Dunne (ed.), *James Barry 1741-1806: 'The Great Historical Painter'* (Kinsale: Crawford Art Gallery and Gandon Editions, 2005).

Brian Fallon, *Edward McGuire, RHA* (Dublin: Irish Academic Press, 1991).

Brian Ferran (ed.), *Basil Blackshaw—Painter* (Belfast: Nicholson & Bass Ltd., 1995).

Nicola Figgis and Brendan Rooney, *Irish Paintings in the National Gallery of Ireland* (Dublin: National Gallery of Ireland, 2001), vol. 1.

Grey Gowrie, *Derek Hill: An Appreciation* (London and New York: Quartet Books, 1987).

Dickon Hall, *Colin Middleton: A Study* (Bangor, Co. Down: Joga Press, 2001).

James Hamilton, *Hughie O'Donoghue: Painting, Memory, Myth* (London and New York: Merrell Publishers Limited, 2003).

John Hewitt, *John Luke (1906-1975)* (Antrim: Arts Councils of Ireland, 1978).

John Hewitt and Theo Snoddy, *Art in Ulster: 1* (Belfast: Blackstaff Press, 1977).

Liam Kelly, *Thinking Long: Contemporary Art in the North of Ireland* (Kinsale: Gandon Editions, 1996).

S. B. Kennedy, *Irish Art and Modernism 1880-1950* (Belfast: The Institute of Irish Studies, The Queen's University of Belfast, 1991).

S. B. Kennedy, *Frank McKelvey* (Blackrock, Co. Dublin: Irish Academic Press, 1993).

S. B. Kennedy, *David Crone: Paintings, 1963-1999* (Dublin: Four Courts Press in association with the Ulster Museum, National Museums and Galleries of Northern Ireland, 1999).

S. B. Kennedy, *Paul Henry* (New Haven and London: Yale University Press, 2000).

SELECT BIBLIOGRAPHY
continued

S. B. Kennedy, *Basil Blackshaw: Paintings 2000-2002* (Belfast: The Blackstaff Press and the National Museums and Galleries of Northern Ireland/Ulster Museum, 2002).

Roderic Knowles (comp. and ed.), *Contemporary Irish Art* (Dublin: Wolfhound Press, 1982).

Adrian Le Harivel (ed.), *National Gallery of Ireland: Acquisitions 1986-88* (Dublin: National Gallery of Ireland, 1988).

Norbert Lynton, *William Scott* (London: Thames & Hudson, 2004).

Kenneth McConkey, *British Impressionism* (Oxford: Phaidon Press, 1989).

Kenneth McConkey, *A Free Spirit: Irish Art 1860-1960* (Woodbridge, Suffolk: Antique Collectors' Club in association with Pyms Gallery, London, 1990).

Kenneth McConkey, *Sir John Lavery* (Edinburgh: Canongate Press, Ltd., 1993).

Elizabeth Mayes and Paula Murphy (eds), *Images and Insights* (Dublin: Hugh Lane Municipal Gallery of Modern Art, 1993).

Dennis O'Driscoll, *Stepping Stones: Interviews with Seamus Heaney* (London: Faber and Faber Limited, 2008).

Marguerite O'Molloy (ed.), *Irish Museum of Modern Art: The Collection* (Dublin: Irish Museum of Modern Art, 2005).

John O'Regan (ed.), *Profile 9: Micheal Farrell* (Oysterhaven, Kinsale, Co. Cork: Gandon Editions, 1998).

Hilary Pyle, *Jack B. Yeats: A Catalogue Raisonné of the Oil Paintings* (London: André Deutsch Ltd., 1992).

Hilary Pyle, *Yeats: Portrait of an Artistic Family* (London: Merrell Holberton Publishers Ltd. in association with the National Gallery of Ireland, 1997).

Lennox Robinson, *Palette and Plough: A pen-and-ink drawing of Dermod O Brien, P.R.H.A.* (Dublin: Browne and Nolan Limited, 1948).

Jeanne Sheehy, *Walter Osborne* (Ballycotton, Co. Cork: Gifford and Craven, 1974).

Theo Snoddy, *Dictionary of Irish Artists: 20th Century: Second Edition* (Dublin: Merlin Publishing, 2002).

Susan Stairs, *The Irish Figurists and Figurative Painting in Irish Art* (Dublin: The George Gallery Montague Ltd., 1990).

James Christen Steward (ed.), *When Time Began to Rant and Rage: Figurative Painting from Twentieth-Century Ireland* (London: Merrell Holberton, 1998).

Ellis Waterhouse, *British 18th Century Painters* (Woodbridge, Suffolk: Antique Collectors' Club, 1981).

Judith C. Wilson, *Conor 1881-1968: The life and work of an Ulster artist* (Belfast: Blackstaff Press, 1981).

Exhibition catalogues
(Arranged by artist or subject)

Robert Ballagh: Artist and Designer: A Retrospective, Dublin, Royal Hibernian Academy, September – October 2006 (essays by Ciaran Carty and Declan Kilberd).

Celtic Splendour: An Exhibition of Irish Paintings and Drawings 1850-1950, London, Pyms Gallery, April – May 1985.

Didymo geminata: Barrie Cooke, Dublin, Kerlin Gallery, November – December 2007 (essay by Declan Long).

David Crone, Belfast, The Fenderesky Gallery at Queen's, November 1991 (Introduction by S. B. Kennedy).

Gerard Dillon 1916-1971: A Retrospective Exhibition, by Oliver Dowling, Brian Ferran, Ted Hickey and Ethna Waldron, Belfast, Ulster Museum and Arts Council of Northern Ireland Galleries, November – December 1972; Dublin, Municipal Gallery of Modern Art, January – February 1973.

Willie Doherty: False Memory, by Carolyn Christov-Bakargiev and Caoimhín Mac Giolla Léith, Dublin, Irish Museum of Modern Art, October 2002 – March 2003.

Ghost Story: Willie Doherty, curated by Hugh Mulholland, text by Daniel Jewesbury and Declan Long, published on the occasion of Northern Ireland's participation in the collateral event of The Fifty-Second Venice Biennale, 2007.

Willie Doherty, ed. by Yilmaz Dziewior and Matthias Mühling, with contributions by Yilmaz Dziewior, Francis McKee and Matthias Mühling, Hamburg, Kunstverein, May – September 2007; Lenbachhaus, Städtische Galerie and Munich, Kunstbau, September 2007 – January 2008.

Willie Doherty: Apparatus, Derry, Void, November 2008 (text by Anne Stewart).

Willie Doherty: Buried, ed. by Fiona Bradley, text by Fiona Bradley and Willie Doherty, Edinburgh, Fruitmarket Gallery, April – July 2009.

Willie Doherty: Requisite Distance, by Charles Wylie, with a contribution by Erin K. Murphy, Texas, Dallas Museum of Art, May – August 2009; Indiana, Snite Museum of Art, University of Notre Dame, Autumn 2010.

T. P. Flanagan, by S. B. Kennedy, Belfast, Ulster Museum, November 1995 – February 1996; Dublin, Hugh Lane Municipal Gallery of Modern Art, March – May 1996; Enniskillen, Fermanagh County Museum, May – August 1996.

Mark Francis, Dublin, Dublin City Gallery The Hugh Lane, January – February 2008; Krems, Galerie Stadtpark, March – April 2008 (texts by Richard Dyer, James Peto and Francis McKee).

Carol Graham, Belfast, Arts Council Gallery, December 1981 – January 1982.

Carol Graham: New Work: Landscape, Belfast, Tom Caldwell Gallery, September – October 1996 (Introduction by S. B. Kennedy).

Carol Graham: Into the darkness, toward the light: A sounding of psyche, Belfast, Engine Room Gallery, October 1999; Dublin, Guinness Hop Store, April – May 2000 (contributions from Carol Graham, S. B. Kennedy and Caryl Sibbett).

Carol Graham: Spirit Magenta, Belfast, Tom Caldwell Gallery, October – November 2001 (Introduction by S. B. Kennedy).

Paul Henry, by S. B. Kennedy, Dublin, National Gallery of Ireland, February – May 2003.

Irish Houses and Landscapes, by Anne Crookshank, Desmond FitzGerald, Desmond Guinness and James White, Belfast, Ulster Museum, June – July 1963; Dublin, Municipal Gallery of Modern Art, August – September 1963.

The Irish Impressionists: Irish Artists in France and Belgium, 1850-1914, by Julian Campbell, Dublin, National Gallery of Ireland, October – November 1984; Belfast, Ulster Museum, February – March 1985.

Irish Portraits 1660-1860, by Anne Crookshank and The Knight of Glin, Dublin, National Gallery of Ireland, August – October 1969; London, National Portrait Gallery, October 1969 – January 1970; Belfast, Ulster Museum, January – March 1970.

Irish Renascence: Irish art in a century of change, London, Pyms Gallery, November 1986 (Introduction by Kenneth McConkey).

Mainie Jellett, by Daire O'Connell, with contributions by Bruce Arnold, Peter Brooke, Anne Crookshank, Paula Murphy and James White, Dublin, Irish Museum of Modern Art, December 1991 – March 1992.

Sir John Lavery R.A. 1856-1941, by Kenneth McConkey, Edinburgh, The Fine Art Society, August – September 1984; London, The Fine Art Society, September – October 1984; Belfast, Ulster Museum, November 1984 – January 1985; Dublin, National Gallery of Ireland, February – March 1985.

William John Leech: An Irish Painter Abroad, by Denise Ferran, Dublin, National Gallery of Ireland, October – December 1996; Quimper, Musée des Beaux-Arts, January – March 1997; Belfast, Ulster Museum, March – June 1997.

Ciarán Lennon: Paintings and Drawings 1972-1992, Dublin, Douglas Hyde Gallery, May – June 1992 (essays by John Hutchinson and Liberato Santoro).

Ciarán Lennon – L'Entre, Dublin, Irish Museum of Modern Art, July – September 1995 (essay by Marian Lovett).

Ciarán Lennon: Hapax, Dublin, National Gallery of Ireland, January – March 2002 (essays by Vicki Mahaffey and Ciarán Lennon).

Ciarán Lennon, Copenhagen, Arken Museum for Moderne Kunst, February – April 2004 (essay by Dorthe Rugaard Jørgensen).

Ciarán Lennon: Lens Askew: Invisible Weight, Untouchable Colour, Dublin, Royal Hibernian Academy, January – February 2009 (Introduction by Patrick T. Murphy; notes by Ciarán Lennon).

SELECT BIBLIOGRAPHY
continued

Hector McDonnell, by Martyn Anglesea. Foreword by John Julius Norwich; Introduction by Martyn Anglesea; essay by Bernd Krimmel; Catalogue of Works by S.B. Kennedy, Belfast, Ulster Museum, December 2003 – March 2004.

Norah McGuiness: Retrospective Exhibition, Dublin, Trinity College, October – November 1968 (Introduction by Anne Crookshank).

Joseph McWilliams: A Troubled Journey 1966-1989, Belfast, Cavehill Gallery, 1989.

Colour on the March: Joseph McWilliams, Belfast, Cavehill Gallery, March 1997 (essay by S. B. Kennedy).

Anne Madden, Dublin, Irish Museum of Modern Art, June – September 2007 (essays by Enrique Juncosa, Anne Madden, Derek Mahon and Marcelin Pleynet).

Elizabeth Magill, Birmingham, Ikon Gallery, April – May 2004; Milton Keynes, Milton Keynes Gallery, July – September 2004; Gateshead, Baltic Centre for Contemporary Art, September – November 2004.

Elizabeth Magill: Chronicle of Orange, London, Wilkinson Gallery, February – March 2008 (essays by Michael Archer and Cherry Smyth).

James Arthur O'Connor, by John Hutchinson, Dublin, National Gallery of Ireland, November – December 1985; Belfast, Ulster Museum, February – March 1986; Cork, Crawford Municipal Art Gallery, March – April 1986.

Roderic O'Conor, by Roy Johnston, London, Barbican Art Gallery, September – November 1985; Belfast, Ulster Museum, November 1985 – January 1986; Dublin, National Gallery of Ireland, January – March 1986; Manchester, Whitworth Art Gallery, March – May 1986.

Hughie O'Donoghue: The Journey, Leeds, Leeds Art Gallery, September – November 2009 (essay by Tanja Pirsig-Marshall; interview between the artist and Michael Peppiatt).

Aloysius O'Kelly: re-orientations: painting, politics and popular culture, by Niamh O'Sullivan, Dublin, Hugh Lane Municipal Gallery of Modern Art, November 1999 – January 2000.

Frank O'Meara and his Contemporaries, by Julian Campbell, Dublin, Hugh Lane Municipal Gallery of Modern Art; Cork, Crawford Art Gallery; Belfast, Ulster Museum, 1989.

Recent Paintings by Daniel O'Neill, Belfast, McClelland Galleries, May – June 1970.

Onlookers in France: Irish Realist and Impressionist Painters, by Julian Campbell, Cork, Crawford Municipal Art Gallery, October – November 1993.

William Orpen: Politics, Sex and Death, by Robert Upstone, with contributions by Professor R.F. Foster and David Fraser Jenkins, London, Imperial War Museum, January – May 2005; Dublin, National Gallery of Ireland, June – August 2005.

Walter Osborne, by Jeanne Sheehy, Dublin, National Gallery of Ireland, November – December 1983; Belfast, Ulster Museum, January – February 1984.

Royal Ulster Academy of Arts: Diploma Collection, by Martyn Anglesea, Belfast, Ulster Museum, Spring 2000.

William Scott, by Ronald Alley and T. P. Flanagan, Belfast, Ulster Museum, June – August 1986; Dublin, Guiness Hop Store, August – September 1986; Edinburgh, Gallery of Modern Art, October – November 1986.

William Scott: Paintings and Drawings, by Simon Morley and Michael Tooby, Dublin, Irish Museum of Modern Art, July – November 1998.

Sean Scully: Die Architektur der Farbe: The Architecture of Colour, Vaduz, Kunstmuseum Liechtenstein, March – May 2006.

Sean Scully: The Art of the Stripe, by Brian Kennedy, Hanover, New Hampshire, Hood Museum of Art, Dartmouth College, January – March 2008.

Treasures from the North: Irish Paintings from the Ulster Museum, by Eileen Black and Anne Stewart, Dublin, National Gallery of Ireland, March – September 2007.

James Glen Wilson R.N. (1827-1863): Landscape and Marine Painter, by Eileen Black, Belfast, Ulster Museum, September 1980.

John Michael Wright: The King's Painter, by Sara Stevenson and Duncan Thomson, Edinburgh, Scottish National Portrait Gallery, July – September 1982.

Jack B Yeats 1871-1957: A Centenary Exhibition, Dublin, National Gallery of Ireland, September – December 1971; Belfast, Ulster Museum, January – February 1972; New York, New York Cultural Centre, April – June 1972.

Articles

Martyn Anglesea, 'Colin Middleton', in Eileen Black (ed.), *Celebrating Ulster Art: 10 Years of the W. & G. Baird Calendar* (Antrim: W. & G. Baird Ltd. in association with the Ulster Museum, 1996), pp. 29-32.

Eileen Black, 'Richard Rothwell (1800-68) and his works in the Ulster Museum' in Harman Murtagh (ed.), *Irish Midland Studies: Essays in Commemoration of N.W. English* (Athlone: The Old Athlone Society, 1980), pp.205-12.

Eileen Black, 'James Glen Wilson of Ireland and Australia: an enigmatic artist', *Irish Arts Review,* Yearbook 1990-91, pp. 99-102.

Eileen Black, 'William Conor', in Eileen Black (ed.), *Celebrating Ulster Art: 10 Years of the W. & G. Baird Calendar* (Antrim: W. & G. Baird Ltd. in association with the Ulster Museum, 1996), pp. 5-8.

Eileen Black, 'Scenes of Ulster Life: The Paintings and Drawings of William Conor', *Irish Arts Review,* Spring 2002, vol. 18, pp. 146-52.

Eileen Black, 'Blackshaw', Basil Blackshaw Baird Group calendar, 2003.

Eileen Black, 'Neil Shawcross', Neil Shawcross Baird Group calendar, 2006.

W. H. Crawford, 'The Patron, or Festival of St Kevin at the Seven Churches, Glendalough, County Wicklow 1813', *Ulster Folklife,* vol. 32, 1986, pp. 37-47.

Anne Crookshank, 'James Latham 1696-1747', *The GPA Irish Arts Review,* Yearbook 1988, pp. 56-72.

Fintan Cullen, 'The Oil Paintings of Hugh Douglas Hamilton', *The Walpole Society,* vol. L, 1984, pp. 165-208.

John Hutchinson, 'The Romantic Landscapes of James Arthur O'Connor', *Irish Arts Review,* Winter 1985, vol. 2, no. 4, pp. 50-54.

S. B. Kennedy, 'Frank McKelvey', in Eileen Black (ed.), *Celebrating Ulster Art: 10 Years of the W. & G. Baird Calendar* (Antrim: W. & G. Baird Ltd. in association with the Ulster Museum, 1996), pp. 25-28.

William Laffan, 'Taste, Elegance and Execution: John Lewis as a Landscape Painter', *Irish Arts Review,* Yearbook 1999, vol. 15, pp.151-53.

William Laffan, 'William Sadler', in William Laffan (ed.), *The Sublime and the Beautiful: Irish Art 1700-1830,* Pyms Gallery, London, 2001, pp. 140-47.

Peter Lord, 'The two lives of John Lewis', *Irish Arts Review,* Spring 2005, vol. 22, no. 1, pp. 114-19.

Brian McAvera, 'The Power of Uncertainty', *Irish Arts Review,* Summer 2005, vol. 22, no. 1, pp.85-90 (Interview with David Crone).

Kenneth McConkey, 'Rustic Naturalism at the Grosvenor Gallery', in Susan P. Casteras and Colleen Denney (eds), *The Grosvenor Gallery: A Palace of Art in Victorian England* (New Haven and London: Yale University Press, 1996), pp. 129-45.

Anne Stewart, 'Hughie O'Donoghue (b. 1953) *Wrestlers', National Art Collections Fund: 2004 Review,* p. 130.

Anne Stewart, 'Willie Doherty (b. 1959) *Apparatus', The Art Fund: 2006 Review,* p. 159.

Anne Stewart and S. B. Kennedy, 'Dermod O'Brien: Abroad and at Home', *Irish Arts Review,* Autumn 2007, vol. 24, no. 3, pp. 74-79.

'The Note Books of George Vertue relating to Artists and Collections in England', *The Walpole Society,* 1929-1930, vol. XVIII: Vertue I.

Ethna Waldron, 'Joseph Malachy Kavanagh: Keeper, Royal Hibernian Academy: Friend and Associate of Walter Osborne', *The Capucin Annual,* 1968, pp. 314-27.

Caroline Walsh, 'Norah McGuiness: The Saturday Interview', *The Irish Times,* 1 May 1976.

PHOTO CREDITS

All photographs are reproduced with the kind permission of
the Trustees of National Museums Northern Ireland

Pages 2, 38-43 © The Estate of Sir John Lavery by courtesy
of Felix Rosenstiel's Widow & Son Ltd, London, 2010

Pages 8-37, 45, 52, 66, 68, 70 photographs © Ulster Museum, 2010

Page 44 © Courtesy of the Estate of Aloysius O'Kelly, 2010

Pages 48, 49 © The Estate of Roderic O'Conor, 2010

Pages 50, 51 © Anthony O'Brien, 2010

Page 54 © The Artist's Family, 2010

Page 55 © Ms Lalli Lamb de Buitlear, 2010

Page 56 © Unknown

Pages 57-59 © Estate of Jack Butler Yeats. Otherwise all rights reserved, DACS, 2010

Page 60 © The Estate of William John Leech, 2010

Page 61 © Courtesy of the Heirs and Successors of Mainie Jellet, 2010

Page 62 © The Estate of Frank McKelvey RHA, 2010

Page 63 © The Estate of Séan O'Sullivan, 2010

Pages 64, 65 © The Estate of John Luke, 2010

Page 67 © By permission of the Conor Estate, 2010

Page 69 © The Estate of Séan Keating, 2010

Pages 71-73 © Pierre le Brocquy, 2010

Pages 74-76 © The Estate of Colin Middleton, 2010

Page 77 © The Estate of Gerard Dillon, 2010

Pages 78, 79 © DACS, 2010

Page 80 © Unknown

Page 81 © The Estate of Norah McGuinness, 2010

Page 82 © The Derek Hill Foundation, 2010

Page 83 © Terence Philip Flanagan, 2010

Pages 84, 85 © Basil Blackshaw, 2010

Pages 86-88 © The Estate of William Scott, 2010

Page 89 © Ms Camille Souter, 2010

Page 90 © Patrick Scott, 2009

Page 91 © The Estate of Micheal Farrell, 2010

Page 92 © Barrie Cooke, 2010

Page 93 © Sean Scully, 2010

Page 96 © Ms Carol Graham, 2010

Page 97 © Robert Ballagh, Artist, 2010

Page 98 © Ms Rita Duffy, 2010

Page 99 © Felim Egan, 2010

Page 100 © Ms Anne Madden, 2010

Page 101 © Courtesy Kerlin Gallery, Dublin, 2010

Page 102 © Joseph McWilliams, 2010

Page 103 © David Crone, 2010

Page 104 © Ciarán Lennon, 2010

Page 105 © Mark Francis, 2010

Page 106 © The Artist, 2010

Page 107 © Hector McDonnell, 2010

Pages 108, 109 © Courtesy of the Artist, 2010

LIST OF ARTISTS